PHILADELPHIA COLLECTS ART SINCE 1940

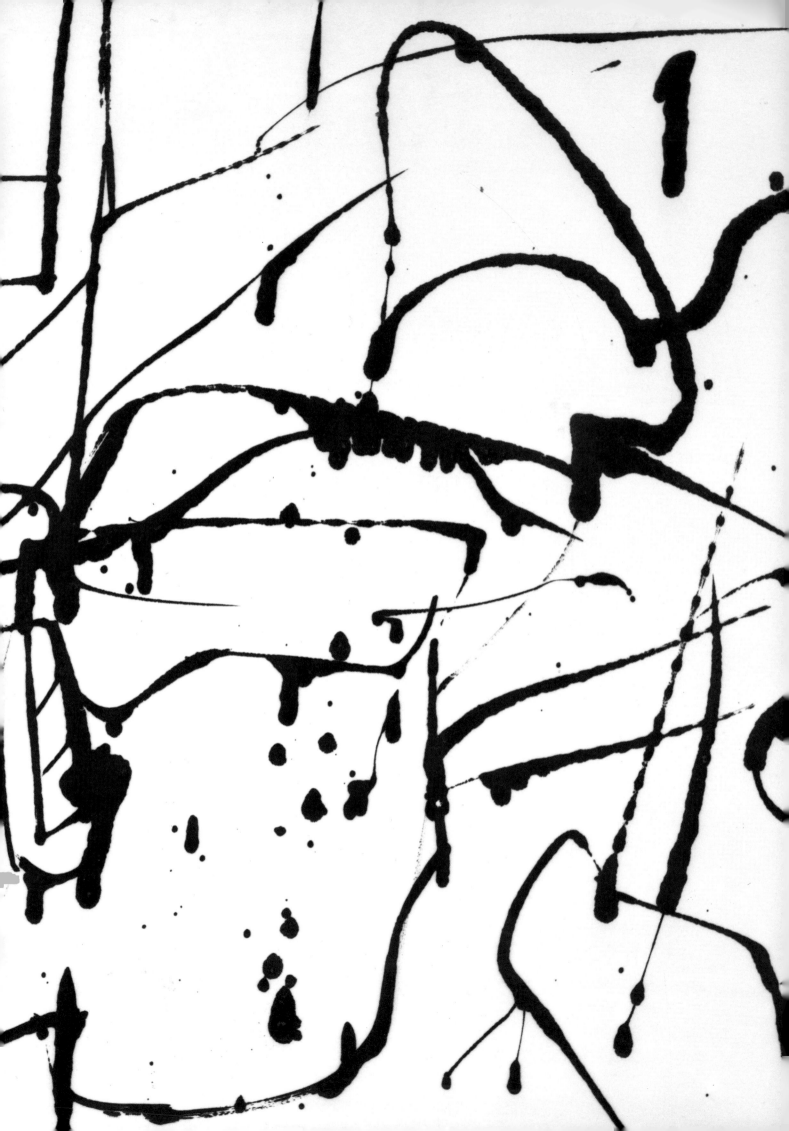

PHILADELPHIA COLLECTS ART SINCE 1940

Organized by Mark Rosenthal
with Ann Percy

Philadelphia Museum of Art
September 28–November 30, 1986

Philadelphia Museum of Art

Distributed by the
University of Pennsylvania Press

The exhibition and catalogue are supported by a grant from The Pew Memorial Trust

Frontispiece
Willem de Kooning
Black and White Composition (detail)

Catalogue text by Amy Ship
Design by Phillip Unetic
Color separations and printing by
Lebanon Valley Offset
Monochrome printing by Cypher Press

Distributed by the University of Pennsylvania Press
Blockley Hall, 418 Service Drive
Philadelphia, PA 19104

Library of Congress Cataloging-in-Publication Data

Rosenthal, Mark (Mark Lawrence)
Philadelphia collects: art since 1940

Includes index.
1. Art, American—Exhibitions. 2. Art, Modern—20th century—United States—Exhibitions. 3. Art, European—Exhibitions. 4. Art, Modern—20th century—Europe—Exhibitions. 5. Art—Private collections—Pennsylvania—Philadelphia—Exhibitions. I. Percy, Ann. II. Philadelphia Museum of Art. III. Title. N6512.R678 1986 709'.04'0074014811 86-22490
ISBN 0-87633-066-9 (pbk.)
ISBN 0-8122-7955-7 (Univ. of Pa. Press ed.)

Photographs by Eric Mitchell, Philadelphia Museum of Art, except the following: William H. Bengtson, p. 115 (bottom); Norinne Betjemann, p. 99 (bottom); Galerie Beyeler, p. 118; Will Brown, pp. 8, 47 (top), 94; Geoffrey Clements, pp. 43 (bottom), 61 (bottom), 117 (right); Ken Cohen, pp. 76, 127 (top); Tom Crane, p. 113 (top); Prudence Cuming Assoc. Ltd., pp. 37 (top), 114 (bottom); Xavier Fourcade, p. 62 (top); Allan Frumkin Gallery, p. 30; eeva-inkeri, pp. 104, 112 (bottom), 116; Franko Khoury, p. 65 (bottom); Jerry Kobylecky, p. 124 (bottom); Bryson Leidick, p. 74 (bottom); Robert E. Mates, p. 105 (bottom); Stephen Mazoh & Co., p. 71 (top); Lawrence Oliver Gallery, p. 121 (bottom); The Pace Gallery, pp. 85 (top), 105 (top), 126 (top); Perls Galleries, p. 47 (top); Sotheby's Parke-Bernet, p. 73; The Tampa Museum, pp. 24, 63; Jerry L. Thompson, p. 98 (top); John Wolfe, p. 72.

CONTENTS

LENDERS TO
THE EXHIBITION

Deborah Allen-Hamalainen

Mr. and Mrs. Dennis Alter

Mr. and Mrs. Theodore R. Aronson

Mr. and Mrs. Philip I. Berman

Benjamin D. Bernstein

Edna S. Beron

Helen and Jack Bershad

Mr. and Mrs. Howard W. Bleiman

Norman and Irma Braman

Hope Byer

James D. Crawford and Judith N. Dean

Mr. and Mrs. Daniel W. Dietrich II

The Honorable Herbert A. Fogel

Mr. and Mrs. Benjamin Frankel

Mr. and Mrs. Jack M. Friedland

Mr. and Mrs. Stephen H. Frishberg

Mr. and Mrs. Melvin Golder

Rachel Bok Goldman

Priscilla Grace

Harvey and Judy Gushner

Anne and Matthew Hall

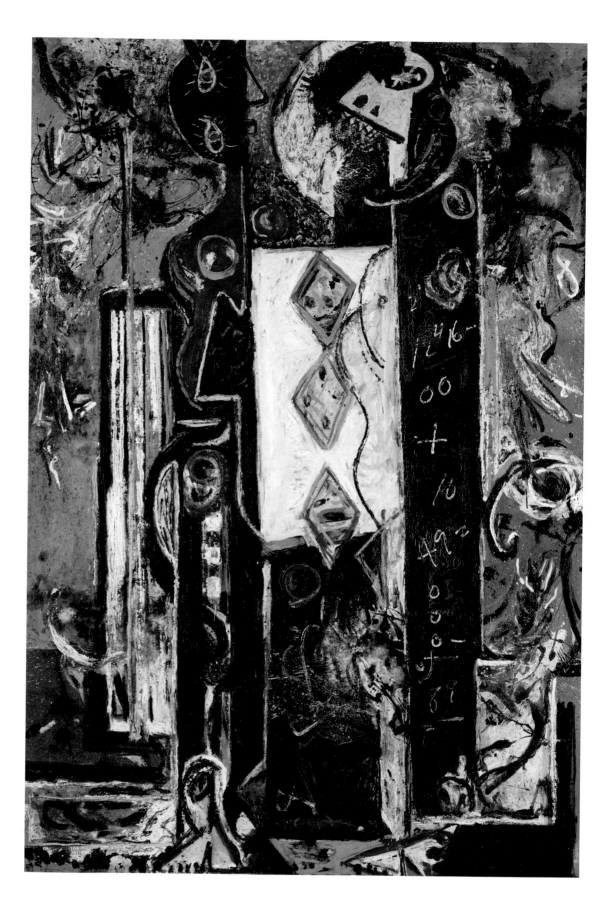

Jackson Pollock
American, 1912–1956
Male and Female
c. 1942
Oil on canvas
73 x 49" (185.4 x 124.5 cm)
Philadelphia Museum of Art.
Gift of Mr. and Mrs.
H. Gates Lloyd

PREFACE

Marcel Duchamp once described the collector as "an artist, au carré." He knew whereof he spoke, as the friend and mentor of a number of remarkable people who formed great collections of modern art in the first half of this century, including Louise and Walter Arensberg whose extraordinary gathering of works by Picasso, Brancusi, Miró, Klee, and other masters (including, of course, Duchamp) now graces the galleries of the Philadelphia Museum of Art. Most of the great museums of the world owe their treasures to generations of individual collectors, whose acquisitive eye first discerned the particular power of an object or an artist. Duchamp's phrase suggests one reason that the appeal of a glimpse into the domain of a private collector remains irresistible—in his or her choices and juxtapositions we find something of the creative inspiration of the artist, whose raw material is the art of others. The degree of "privacy" varies as greatly as does the content of collections. A. E. Gallatin chose to hang his treasures on public view in a study hall in the library of New York University during the 1930s, while the Arensbergs' Hollywood house seemed a relatively remote and magical place where rights of entry belonged to a limited circle. But the true collector rarely resists opportunities to communicate his passion, or to learn from the response of others, and we are enormously grateful to all those who have lent objects to this exhibition for their willingness to share them with a wide audience. The generous support of the Pew Memorial Trust has made it possible to mount the exhibition and publish the catalogue, and the efforts of many people on the Museum staff have brought this project to fruition.

In making their selection, the Museum's curators Mark Rosenthal and Ann Percy found themselves delighted and literally overwhelmed by the abundance of works of art created over the past forty-five years collected in the Philadelphia area. The exhibition was

initially proposed as a survey of art since 1900 in all mediums, but clearly the inclusion of prints, photographs, and crafts (present in Philadelphia in impressive quality and number) would swell the exhibition to impossible proportions—and those pleasures are being reserved for future projects. Since the Museum's 1963 exhibition *Philadelphia Collects 20th Century* inevitably concentrated on the first fifty years, this venture emphasizes the past three decades but includes a selection of works by earlier masters whose influence continues to reverberate.

Patterns of collecting in any large city reflect the resources of the city itself, as well as the independent vision and taste of the collectors, and the Introduction to this catalogue identifies a number of those resources that make Philadelphia a lively cultural center. We all owe warm thanks to sister institutions large and small whose activity in the contemporary field stimulates the interest so evident here.

The Museum's own resources are surely part of that stimulus: the presence of superb collections of early modern art and the conviction on the part of Trustees, supporters, and staff that the exhibition and acquisition of the art of our own time are an integral part of our mission. We are most grateful to the members of the Museum's advisory Committee on Twentieth-Century Art for their collective encouragement over the years, as well as for their many individual acts of generosity in support of contemporary art at the Museum.

In saluting the enthusiasm of the current generation of collectors upon the occasion of this exhibition, celebrating the memory of a remarkable woman, whose own pursuit of the new as a collector led her from Mondrian to Gerhard Richter, from Pollock's magisterial *Male and Female* to Rafael Ferrer's *Arrogant Man from the Tropics*, is particularly appropriate. Mrs. H. Gates Lloyd served as a Trustee of the Museum for many years and was Chairman of the Committee on Twentieth-Century Art at the time of her death. Her spirited advocacy of modern art and artists, whether at the Museum, the Institute of Contemporary Art at the University of Pennsylvania, the Philadelphia College of Art, or in the city at large, exerted a profound influence and set a high standard.

Response to contemporary art must always be an intensely personal matter. The attraction of the collector to a particular work of art, the choices of the curator, and the response of the viewer to the works of art exhibited all contribute to a complex dialogue about the nature of art and the temper of the time in which it is created. Above all, it is the artists themselves to whom we must be grateful for creating that potential intensity of experience for all of us, which is there for the looking.

Anne d'Harnoncourt
The George D. Widener Director

FOREWORD

Philadelphia rejoices in a burgeoning art scene: there is a thriving community of artists; nonprofit institutions are exhibiting and acquiring contemporary art at a rapidly increasing rate, commercial galleries are expanding, corporations are developing collections of their own, and other new ventures in the field are appearing. This vitality is fired by a growing audience for the art of our time, and a crucial part of that growth is an ever-increasing group of collectors whose enthusiasm and support make it possible for the institutions committed to contemporary art to thrive.

Our goal in organizing this exhibition of contemporary art from Philadelphia collections was to strike a balance, however imprecise, between presenting a survey of art since 1940 and revealing the acquisition patterns and predilections of Philadelphia area collectors. To do so in the available exhibition space has been most difficult, and we have had, on occasion, to forgo works of fine quality. Moreover, we are sure to have missed some collectors who possess particularly interesting pieces. Within the catalogue the works have been grouped into categories, but it should be emphasized that these divisions are not meant to define fully the character of each artist's endeavor.

The collectors who have parted with their treasures for the exhibition have been most generous, and they have been unfailingly kind in providing information whenever asked. Certainly the most enjoyable aspect of organizing the exhibition has been the opportunity to become acquainted with a wide circle of people who care passionately about the art of our time.

Many persons have helped in this adventure, suggesting collections to be visited or providing information to help understand the evolving contemporary scene in Philadelphia over recent years. We want, in particular, to acknowledge the generous help of Barbara Aronson, Luther Brady, Paul Cava, Chuck Fahlen, Janet Fleisher, Frank Goodyear, Janet Kardon, Marian Locks, Elsa Weiner Longhauser, Hope and Paul Makler, Benjamin Mangel, Larry Mangel, John Ollman, David and Gerri Pincus, Eileen Rosenau, Judy Stein, Mimi Stein, Marion Stroud Swingle, the late Bonnie Wintersteen, and Acey Wolgin.

Amy Ship, Curatorial Assistant in the Department of Twentieth-Century Art, has worked determinedly to keep the many details of this project on track. She is also responsible for the lucid introductions to each section of plates. Phillip Unetic has created a lively design for the catalogue; Eric Mitchell carried out the program of photographing a great many works of art in the homes of the collectors; and George Marcus did an admirable job of organizing the catalogue as a whole. Grace Eleazer was responsible for the complex shipping arrangements. We would like to acknowledge gratefully the contributions of the following: Irene Taurins, Registrar; Tara Robinson, Installation Designer; Suzanne Wells, Special Exhibitions Coordinator; Marigene Butler, Head Conservator; Jesse Baker, Framing Technician; P. Andrew Lins, Conservator of Decorative Arts; Melissa Meighan, Assistant Conservator of Objects; Suzanne Penn, Associate Conservator for Special Projects and Exhibitions; Denise Thomas, Associate Conservator of Works on Paper; and Conna Clark, Manager of Rights and Reproductions. We would also like to thank Judith Boust and Charles Field, Publications; T. S. Farley, Hal Jones, and Michael MacFeat, Packing; Helene Voron, the Friends of the Museum; and Margaret Kline and Adriana Ernst, Twentieth-Century Art.

The late Mrs. H. Gates Lloyd—"Lallie" as she was affectionately known—made an extraordinary contribution to the appreciation of contemporary art in Philadelphia, not only in her role as a distinguished collector but also as a partisan, patron, and founder of many activities in the field of exhibitions and collecting. Mrs. Lloyd's position in the community was singular, and we are pleased to take this opportunity to celebrate her.

M.R. / A.P.

INTRODUCTION

Passion drives the collector of works of art, for the aesthetic experience is exhilarating. It evokes sensuous delight, provokes thought, and touches spiritual feelings. Imbued with the love of art, the collector's life is filled with the adventure of finding and acquiring beautiful works of art. The excitement of discovery is equaled by the delight in owning a treasure. A work of art is unlike anything we encounter in our daily lives; in a tangible sense, the arts constitute a vehicle by which individuals express deeply personal concerns and whole civilizations may reveal profound qualities about themselves. Possession of a great work of art suggests contact with the most elevated impulses.

Often, the activity of art collecting becomes a way of life. Wanting to know as much as possible about these objects of veneration, the collector becomes an amateur—or occasionally even a professional—art historian or critic. Art, after all, is a complex matter and should be explored on every level, so the collector, weighed down by books and catalogues, seeks an intellectual understanding of this subject. Travel assumes great importance, as visits to museums, galleries, and studios sharpen perceptions and provide aesthetic pleasure. Collectors find abiding friendships with others who share their ardor, including artists, critics, dealers, curators, and fellow collectors, and these associations often affect the patterns and pleasures of collecting.

Philadelphia has a distinguished tradition of private collectors. In the field of twentieth-century art, they have been independent in their outlook, collecting everything from established masters to adventuresome new talents. Indeed, the ardor of Philadelphians is now such that galleries can introduce the work of unknown artists with some expectation that collectors here will make thoughtful judgments about acquiring such work. It

should be recognized that while collecting can require considerable income, many collectors, in fact, spend modest sums of money in pursuit of their dreams. If one is adventurous and persistent in the search for quality, one can acquire beautiful and original objects.

By the 1950s there was a small group of patrons in the city devoted to the most recent developments in art. They encouraged others, and gradually forums devoted to national and international tendencies in contemporary art began to flower. The first of these was the remarkable series of thematic exhibitions organized by the Arts Council of the YM/YWHA, from the late 1950s until about 1970. Among the artists whose works were shown were Arman, Jim Dine, Mark di Suvero, Nancy Graves, Robert Hudson, Jasper Johns, Allan Kaprow, Les Levine, Roy Lichtenstein, Marisol, John McCracken, Louise Nevelson, Claes Oldenburg, Robert Rauschenberg, Ed Ruscha, Richard Serra, Jean Tinguely, and Wayne Thiebaud. Accompanying the exhibitions were programs of lectures, dance, theater, and poetry events that made the "Y" one of the first truly ambitious platforms for contemporary artistic activity in the city.

In 1963, shortly after the "Y" had opened the door, the Institute of Contemporary Art was established at the University of Pennsylvania. The ICA initiated a truly outstanding record of exhibitions, starting in the early years with the first solo shows in the United States to be devoted to Andy Warhol and Tony Smith and with retrospectives of Clyfford Still, David Smith, Rafael Ferrer, William T. Wiley, Agnes Martin, Cy Twombly, and Robert Rauschenberg. In more recent years, Philadelphians have seen exhibitions of works by a range of artists including Richard Artschwager, Neil Welliver, Laurie Anderson, and Siah Armajani.

The Friends of the Philadelphia Museum of Art was founded in 1964 to raise acquisition funds for the Museum. While all curatorial departments of the Museum have been enriched through the generous efforts of the Friends, the contemporary field continues to gain particular benefit. With acquisitions early on of works by artists such as Robert Rauschenberg and Frank Stella, the supporters of contemporary art ensured that the achievements of our time would remain in the city. The Friends' acquisitions for the Museum over the past decade include works by Jean Dubuffet, Ellsworth Kelly, Jim Dine, George Segal, and Anselm Kiefer.

The appreciation of contemporary art in the city during the 1960s was reinforced and encouraged by the presence of a small group of ardent and persuasive dealers who were able to offer a counterbalance, to some extent, to the ongoing allure of New York as the international center of the art world. These galleries made available to a Philadelphia audience the art of important regionally, nationally, and internationally recognized figures.

The vitality of the 1960s gathered force through the 1970s. The Philadelphia Museum of Art exhibited the work of Marcel Duchamp, Jasper Johns, Claes Oldenburg, and Isamu Noguchi, and sponsored site-specific works by Christo, Gene Davis, and Rockne Krebs. The Museum's own holdings of contemporary art expanded significantly with gifts of substantial collections, such as those formed by the Woodward Foundation and by Albert and Elizabeth Greenfield, complemented by gifts and purchases of individual works.

Philadelphia has always been an active center for the study of the history of art and the education and training of artists, and over the past decades teaching institutions have had an important impact on the education of the collector. Possibly the most important in this regard is the Barnes Foundation. Notable for its unwavering, formal approach, it is the institution at which a formidable number of area collectors and aficionados received their first intensive exposure to the study of works of art. Moreover, both the astonishing example set by Albert Barnes as a collector in the first quarter of this century and his vast and

impressive collection itself have provided a remarkable stimulus to young collectors. Within its ongoing program, the Pennsylvania Academy of the Fine Arts devoted several important exhibitions during the 1970s to contemporary modes of realism, and recent offerings have ranged from Red Grooms to Franz Kline, while the galleries of Moore College of Art, the Philadelphia College of Art, and Tyler School of Art at Temple University have actively exhibited a wide range of recent art and have periodically introduced the work of their students and faculty to the public.

The presence of a large, varied, and lively community of artists in the city has contributed immeasurably to Philadelphia's interest as a center for contemporary art, and several institutions particularly devoted to artists associated with the city have had an important, cumulative influence. Long-established exhibitions and programs such as those at the Cheltenham Art Centre, Woodmere Art Museum, Philadelphia Art Alliance, and Print Club of Philadelphia were joined in the 1970s by a number of new enterprises. The Nexus and Muse galleries, which opened in 1976 and 1977 respectively, helped introduce the cooperative gallery concept to the city. A series of "Challenge Exhibitions" devoted to emerging artists began in 1978 at the Fleisher Art Memorial. Sponsored by the Pennsylvania Academy, the Peale House exhibitions were succeeded by the Morris Gallery program in the Academy itself, which began in 1978 and serves as a major venue for the exhibition of new work by regional artists.

As interest in contemporary art evolved during the 1970s, a greater variety of art and art enterprises became available. The Brandywine Graphic Workshop opened in 1972, for example, providing a printmaking facility, and a succession of organizations was devoted to performance art. The number of commercial galleries and alternative spaces gradually increased throughout the 1970s. The vigorous craft movement became an important focus of Philadelphians' interest, and several important galleries and nonprofit enterprises were founded, including the highly innovative Fabric Workshop, making the city a center for the interaction of the crafts with other media.

It seems fair to assert that the current decade reflects the greatest interest in contemporary art in Philadelphia to date. Museums have dramatically increased their exhibitions and collecting activity, and the city has developed a gallery scene of hitherto unimagined vitality. The news media have expanded coverage of the arts, and new publication ventures have emerged to survey the scene. City government, too, has become a patron of the arts, as exhibitions now occur regularly in various public spaces. Philadelphia has a remarkable history as a center for outdoor public sculpture, with monuments such as Alexander Milne Calder's *William Penn* atop City Hall and Claes Oldenburg's *Clothespin* of 1976 directly across the street. This tradition has been proudly remarked upon and enhanced during the 1980s, culminating recently with the dedication of Isamu Noguchi's *Bolt of Lightning*.

To chart the kaleidoscopic changes that have occurred in Philadelphia, one need only compare the Museum's 1963 exhibition devoted to area collections, *Philadelphia Collects 20th Century,* with the present exhibition to realize that there has been an explosion of interest in contemporary art. With this explosion, the overall art scene of Philadelphia has benefited enormously. An active corps of collectors enhances the viability of programs of contemporary art in museums, galleries, and art schools. It becomes feasible for artists to remain rooted in the city if it offers a sympathetic audience and the prospect of sales. With an active art scene, the collector in turn gains a primary source of knowledge and a context by which judgments can be tested. Hence, the ostensibly private adventure of art collecting is not only personally satisfying but also has far-reaching effects on the artistic life of the community, an effect for which all can be grateful.

M.R.

LIST OF ARTISTS

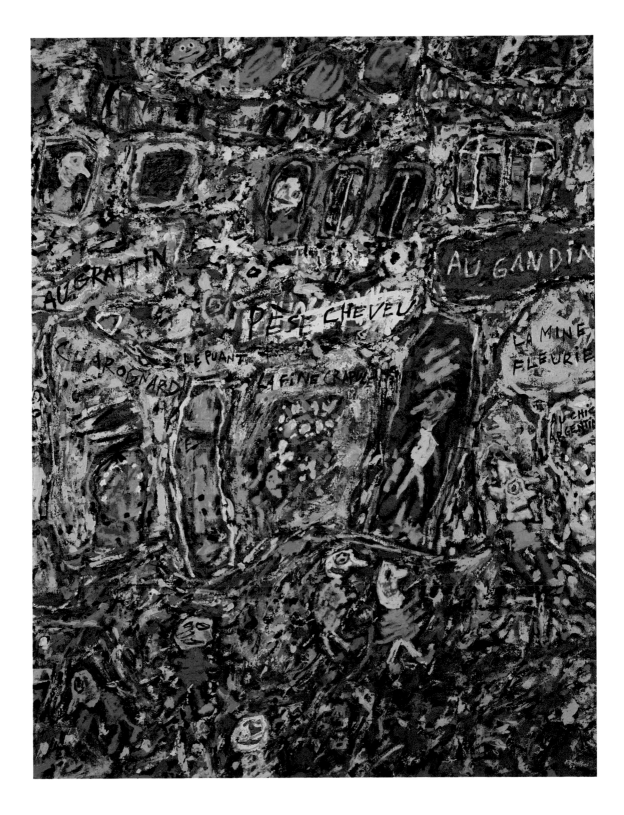

Jean Dubuffet
French, 1901–1985
Pèse cheveu
1962
Oil on canvas
77 x 59″ (195.6 x 149.9 cm)
Collection of Dr. and Mrs. Paul
Todd Makler

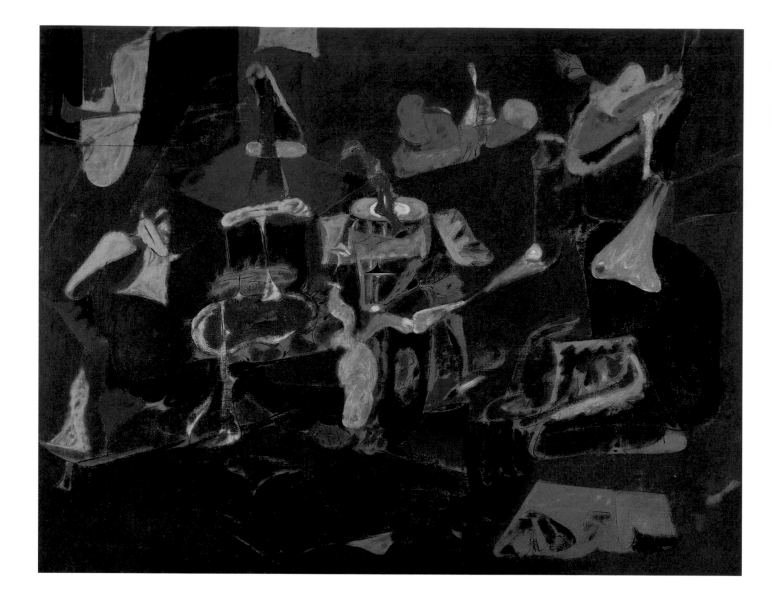

Arshile Gorky
American, born Armenia,
1904–1948
Dark Green Painting
c. 1948
Oil on canvas
43¾ x 55¾" (111.1 x 141.6 cm)
Collection of H. Gates Lloyd

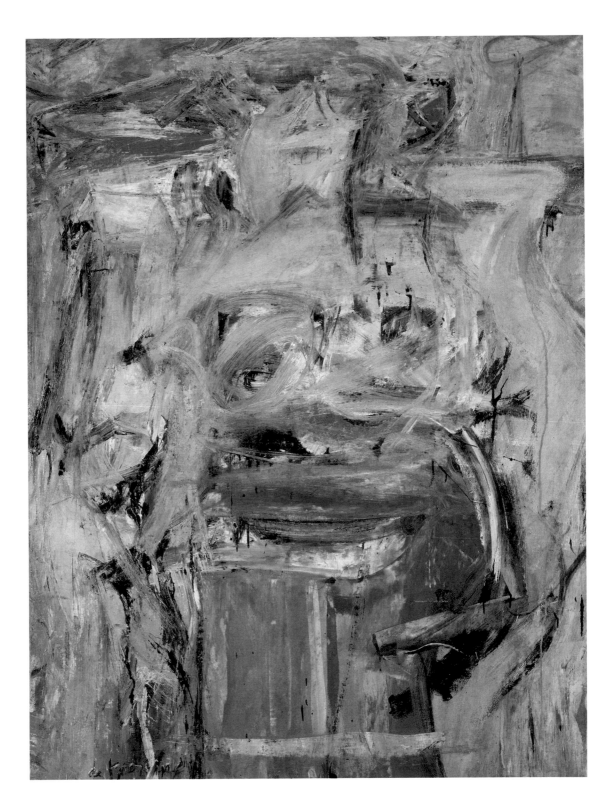

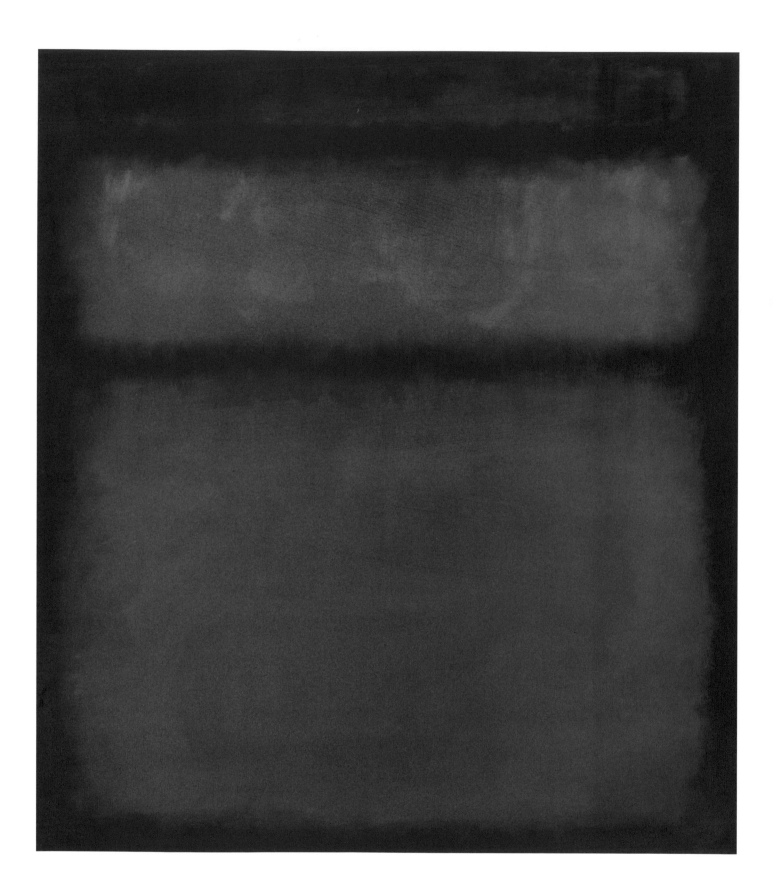

Mark Rothko
American, born Russia,
1903–1970
Orange, Red, and Yellow
1961
Oil on canvas
93 x 81" (236.2 x 205.7 cm)
Private collection

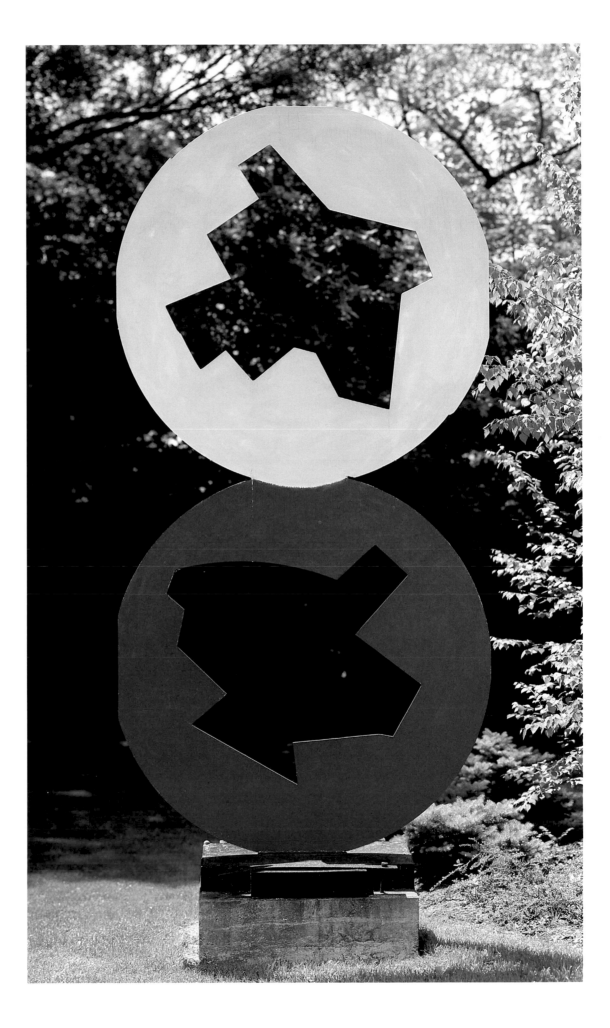

David Smith
American, 1906–1965
2 *Circles IV*
1962
Painted steel
Height 10′4″ (3.2 m)
Private collection

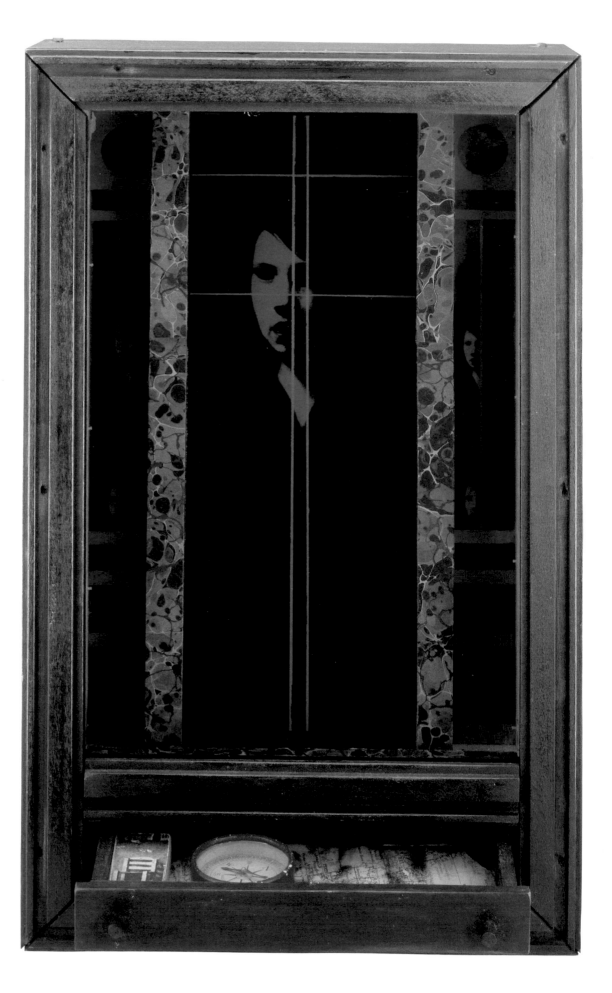

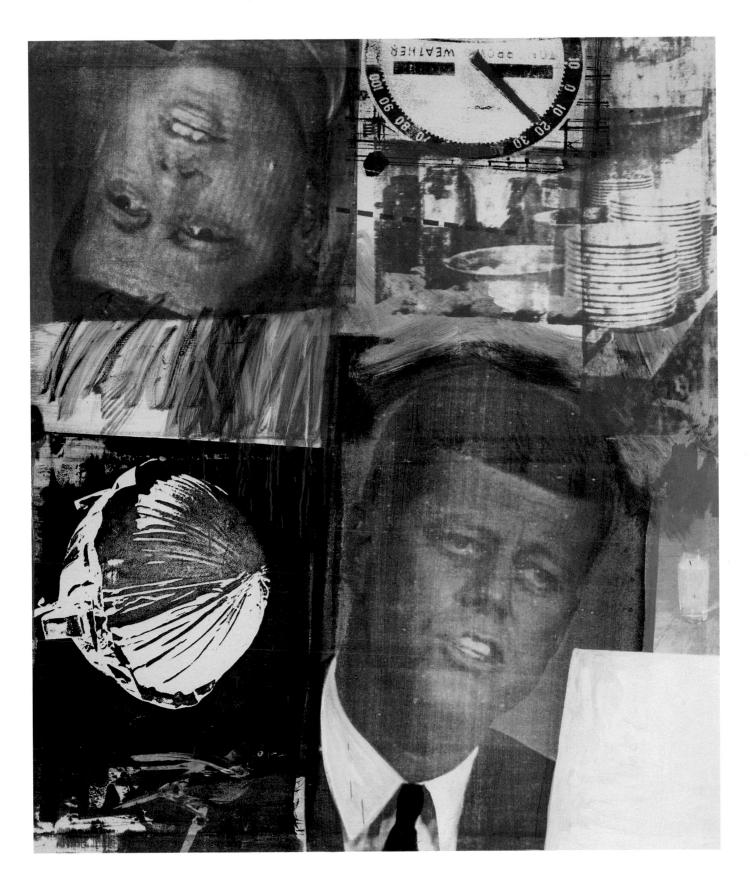

Robert Rauschenberg
American, born 1925
Untitled
1964
Photo-silkscreen and oil on
canvas
58 x 50" (147.3 x 127 cm)
Collection of Mr. and Mrs.
Robert Kardon

Frank Stella
American, born 1936
Great Jones Street
1958
Oil on canvas (two sections)
Each 96 x 57"
(243.8 x 144.8 cm)
Collection of Norman and Irma
Braman

Warren Rohrer
American, born 1927
Painting: From Black 3
1979
Oil on canvas
60 x 60″ (152.4 x 152.4 cm)
Collection of Gene and
Sueyun Locks

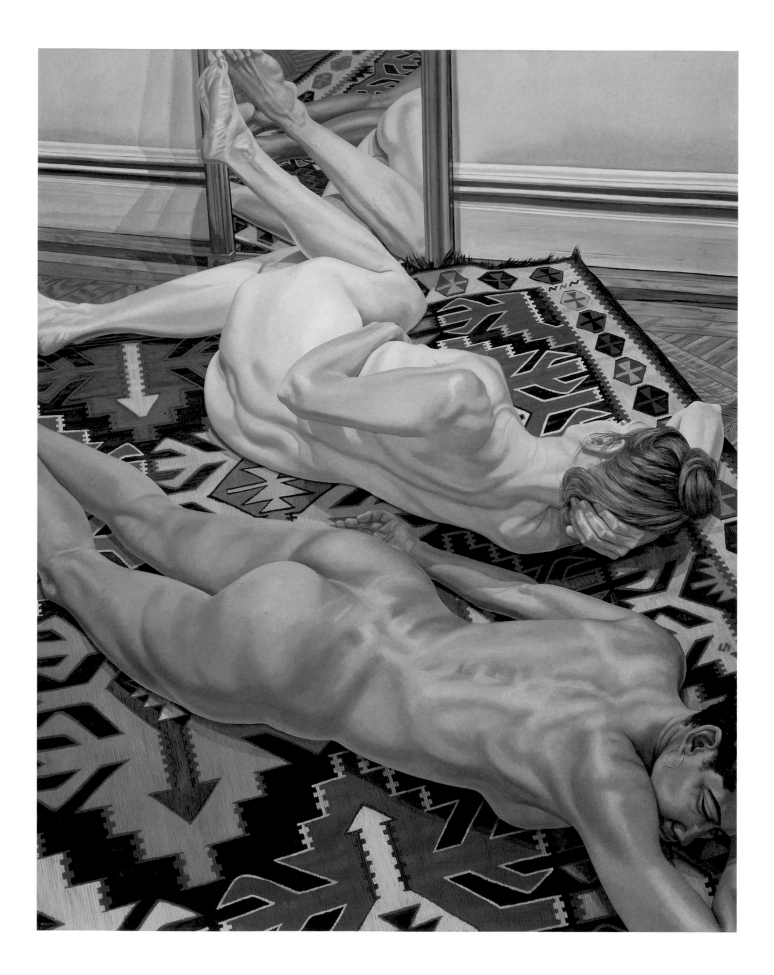

Philip Pearlstein
American, born 1924
*Two Models on Kilim Rug
with Mirror*
1983
Oil on canvas
90 x 72" (228.6 x 182.9 cm)
Collection of Jane and
Leonard Korman

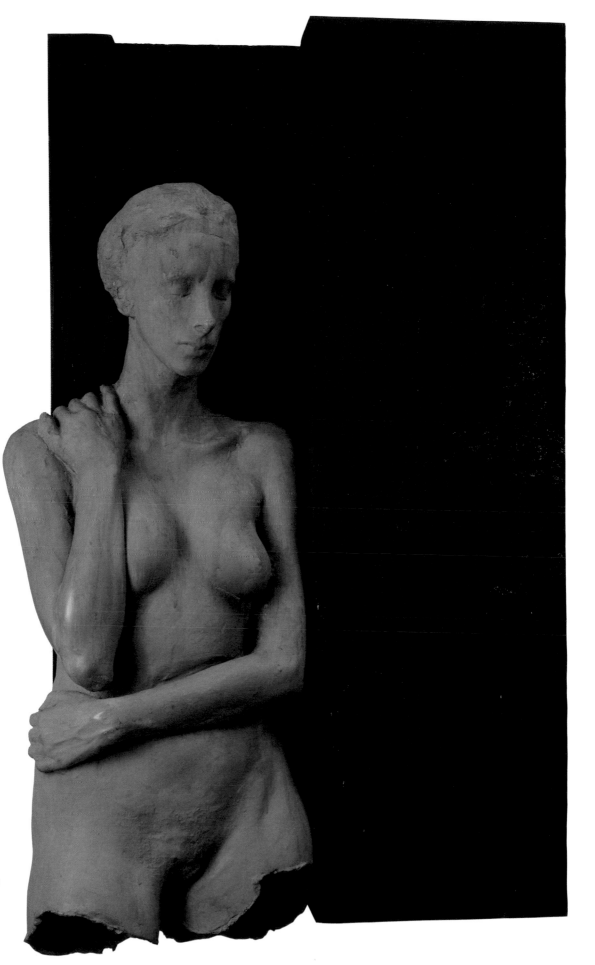

George Segal
American, born 1924
Blue Girl against Barn Wall
1977
Painted plaster and wood
50 x 30 x 15" (127 x 76.2 x
38.1 cm)
Collection of Mr. and Mrs.
Jack M. Friedland

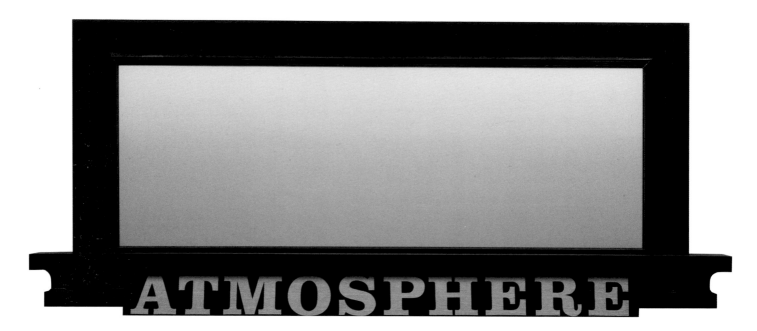

Neil Jenney
American, born 1945
Atmosphere
1975–85
Oil on panel
33 x 79½″ (83.8 x
201.9 cm)
Collection of Mr. and Mrs.
Keith L. Sachs



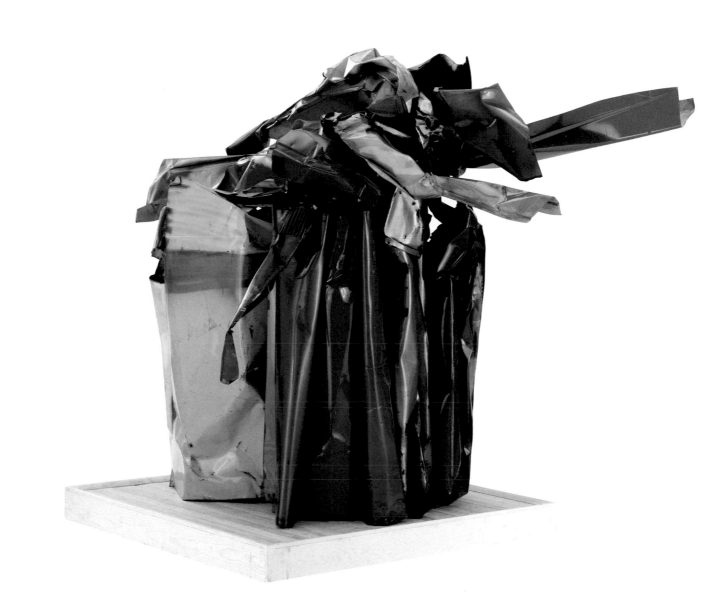

John Chamberlain
American, born 1927
Glossalia Adagio
1984
Painted and chromium-plated
steel
Height 80″ (203.2 cm)
Private collection

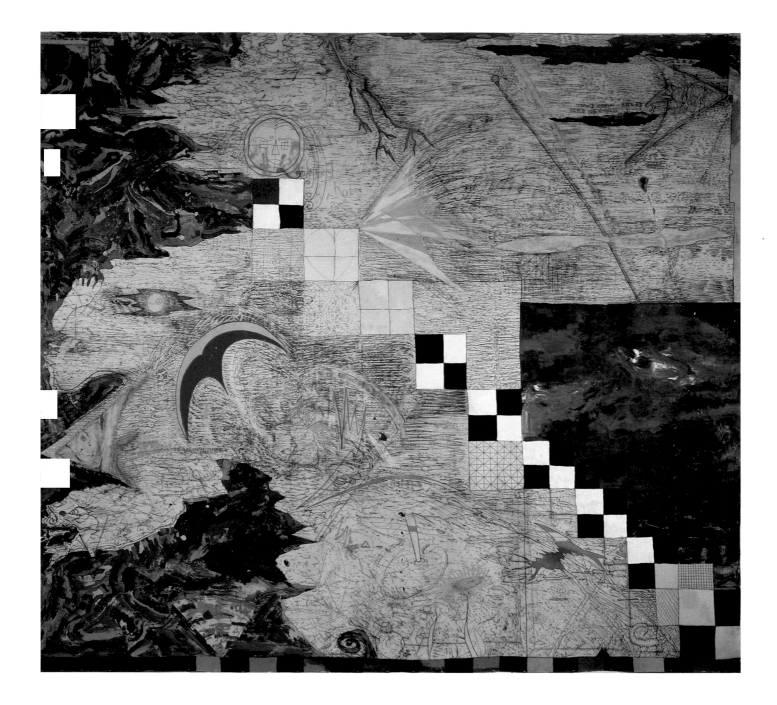

William T. Wiley
American, born 1937
*Imp Your Deck Oration on
the Level*
1983
Acrylic and charcoal on
canvas
8 x 9' (2.4 x 2.8 m)
Collection of Harvey and
Judy Gushner

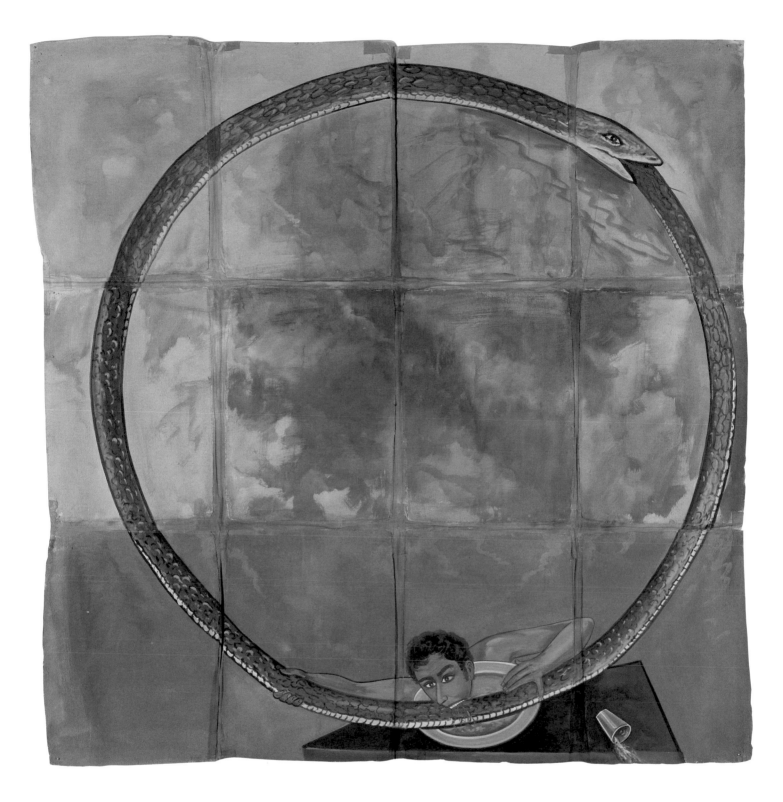

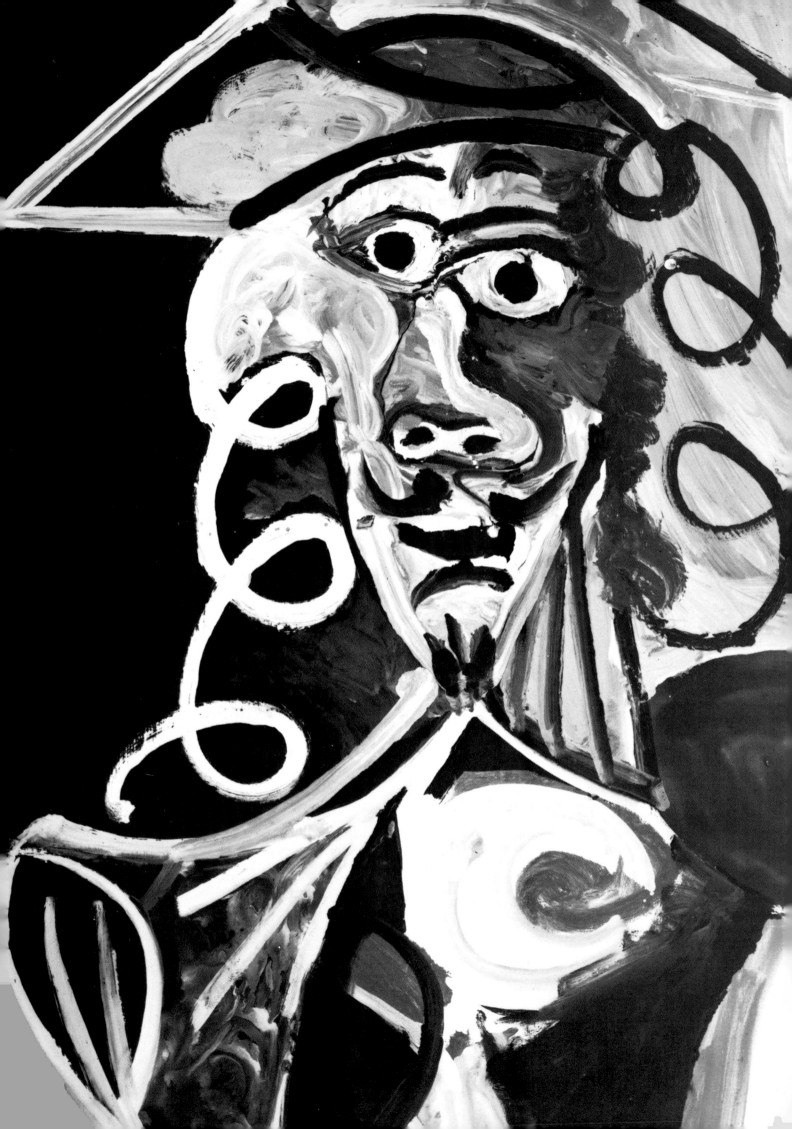

EUROPEAN FORERUNNERS

The diverse approaches of early twentieth-century European painters and sculptors to the task of making art suggested an abundance of directions for innovations in the second half of this century. A number of the great pioneer figures, such as Picasso, continued to make astonishing additions to their creative vocabulary at the same time that their own early work executed a powerful influence upon generations of younger artists, both in Europe and the United States.

Many European artists after World War II expanded upon the liberating aspects of the Surrealist movement. Painters, poets, and philosophers, inspired in part by the writings of Freud and Jung, adopted a doctrine of antirationalism, urging that creativity spring from impulses of the psyche uncensored by the intellect. Exploring techniques of automatism, accident, and free association, artists turned to fresh sources of imagery: dreams, fantasy, the unconscious. Roberto Matta offered turbulent inner visions, while Jean Dubuffet championed the creative power of untrained expression in the child and the madman. Surrealism also stimulated new directions in sculpture, from Henry Moore's monumental organic forms to Alberto Giacometti's lonely, attenuated standing figures. Many works by European artists of the 1940s and 1950s prefigure the emergence of Abstract Expressionism in this country. At the same time, masters of pure abstraction, such as Piet Mondrian, continued to explore new realms of balance and harmony that offered alternative paths to artists of the midcentury.

Pablo Picasso
Bust of a Man (detail)

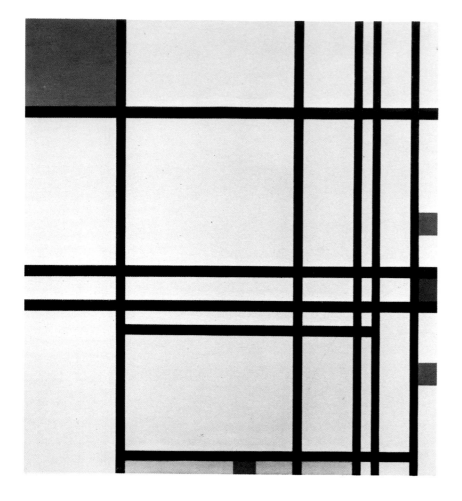

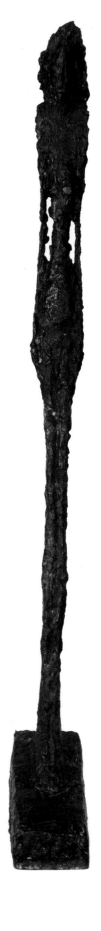

Piet Mondrian
Dutch, 1872–1944
Composition
1939–42
Oil on canvas
29½ x 27" (74.9 x 68.6 cm)
Collection of H. Gates Lloyd

Alberto Giacometti
Swiss, 1901–1966
Standing Woman with Hairdo
1949
Bronze
Height 61" (154.9 cm)
Collection of Norman and
Irma Braman

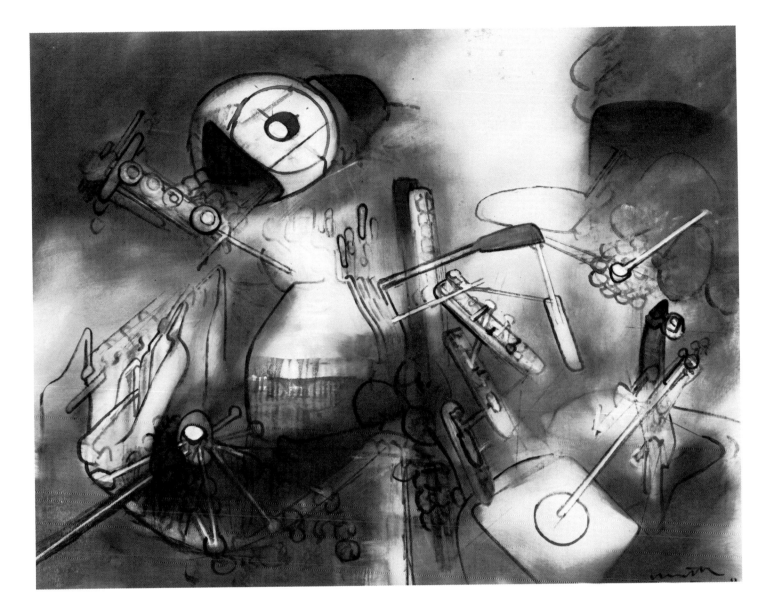

Roberto Matta
Chilean, born 1911
Untitled
1963
Oil on canvas
44½ x 57¼" (113 x 145.4 cm)
Collection of Jack and Muriel
Wolgin

Pablo Picasso
Spanish, 1881–1973
*Still Life with Chair and
Gladiolas*
1943
Oil on canvas
57⅜ x 44⅝"
(145.7 x 113.3 cm)
Collection of Mr. and Mrs.
Raymond G. Perelman

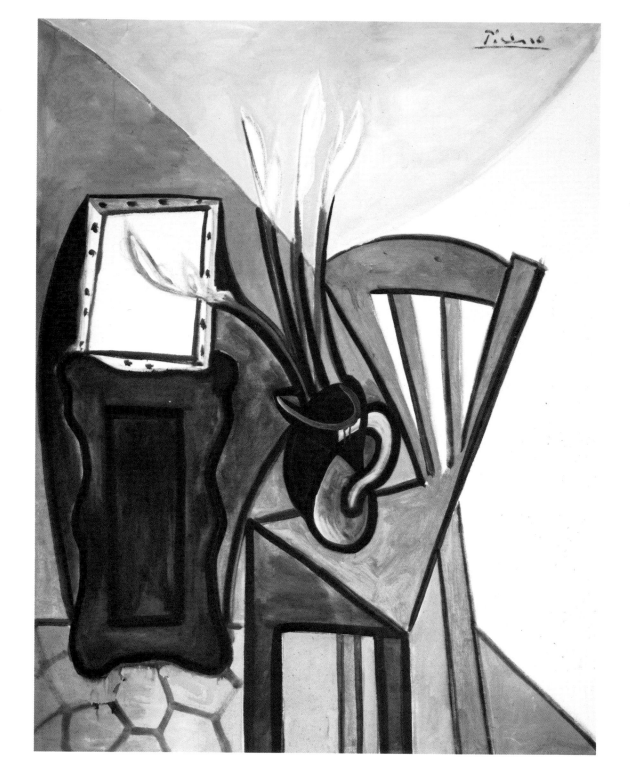

Pablo Picasso
Spanish, 1881–1973
Aubade
1967
Oil on canvas
51⅞ x 76¾″ (131.8 x 194.9 cm)
Collection of Mr. and Mrs.
Philip I. Berman

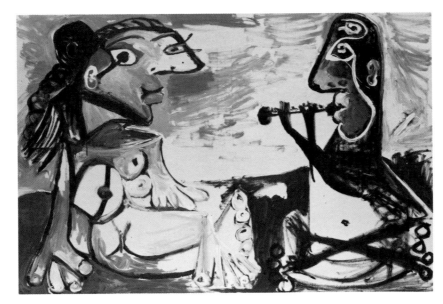

Pablo Picasso
Spanish, 1881–1973
Bust of a Man
1969
Oil on canvas
51⅜ x 38⅜″ (130.5 x 97.5 cm)
Private collection

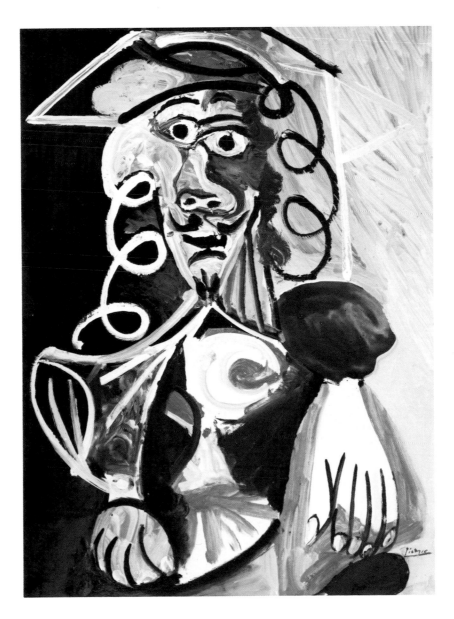

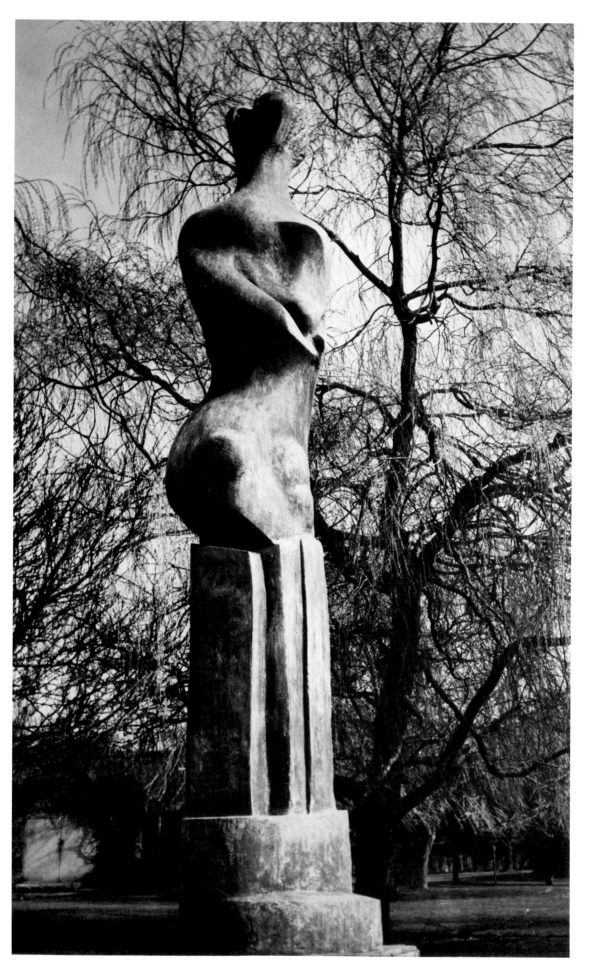

Henry Moore
British, 1898–1986
Upright Motive No. 9
1979
Bronze
Height 10′6″ (3.2 m)
Collection of Mr. and Mrs.
Philip I. Berman

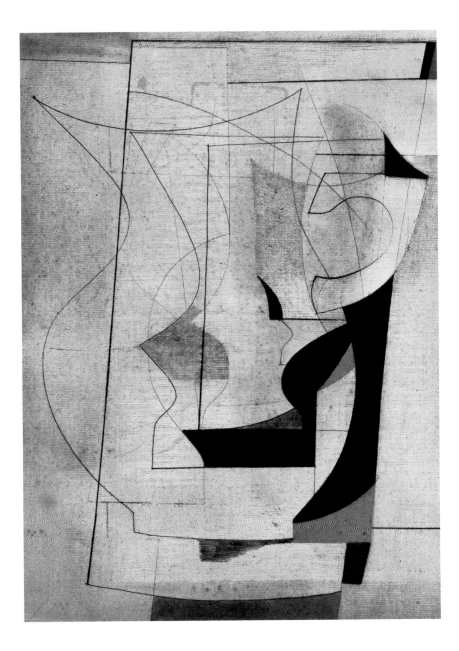

Ben Nicholson
British, 1894–1982
July 26, 1953 (Ceramic)
1953
Oil on board
13¾ x 9¾" (34.9 x 24.8 cm)
Private collection

Elisabeth Frink
British, born 1930
Wild Boar
1975
Bronze
Height 28" (71.1 cm)
Collection of Benjamin D.
Bernstein

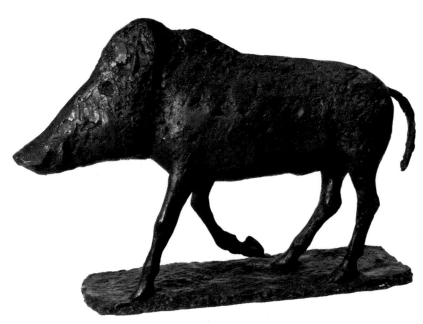

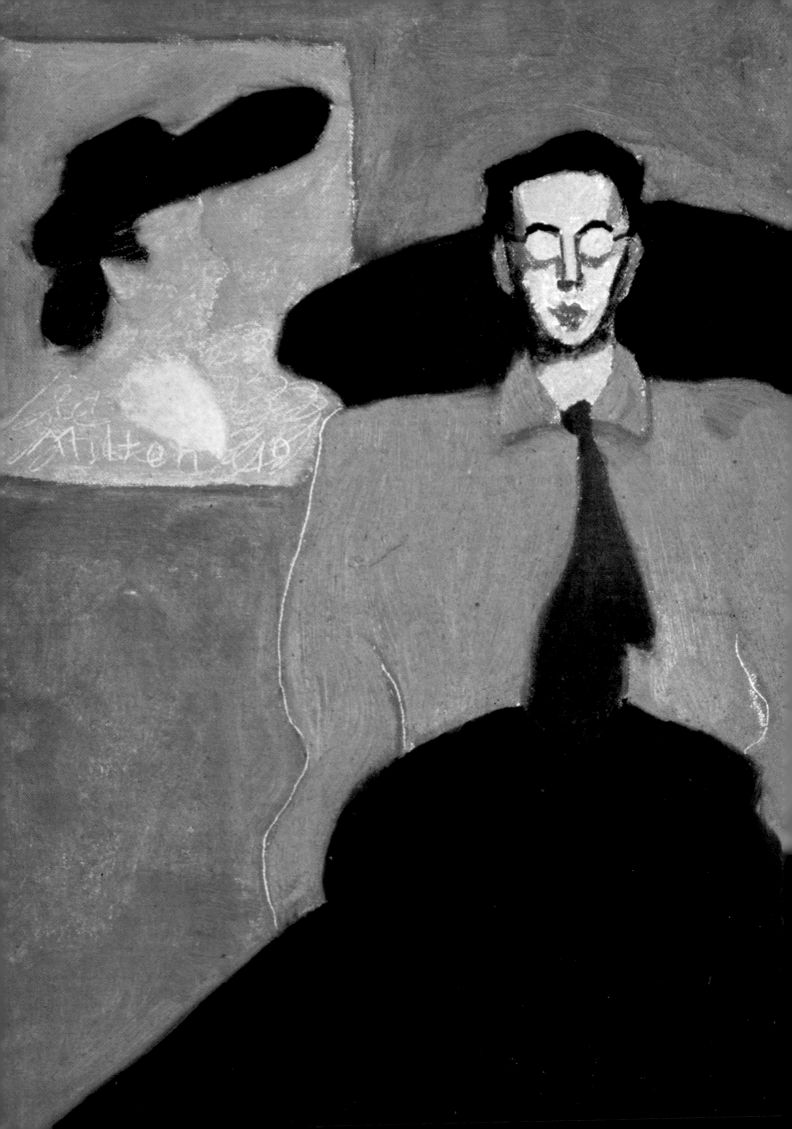

AMERICAN MAVERICKS

During the 1930s and 1940s, schools of American painting, such as Social Realism, continued to have prevailing influence, but ideas and modes from Europe began to alter the ways in which American artists thought and worked. The works of Jacob Lawrence and Philip Evergood, originating within the American realist tradition, continued to explore American themes and scenes in a narrative format, each imbued with its own idiosyncratic poetry. Other American artists, working independently, began to explore the approaches of the European masters. Milton Avery, inspired by Matisse, abstracted his figures into flattened color shapes; Stuart Davis, influenced by Synthetic Cubism, incorporated words and linear shapes into his energetic paintings of city life. Alexander Calder and Joseph Cornell, encouraged by aspects of Surrealism, invented new forms of artistic expression. Calder used wire to experiment with continuous line in space and developed his stabiles and mobiles. Cornell combined small objects into box constructions of supreme evocative power. Although never perceived as a unified group, these artists gave unique character to a transitional period in American art.

Milton Avery
Man and Wife (detail)

Jacob Lawrence
American, born 1917
Radio Repairs
1946
Gouache on paper
21½ x 29½″ (54.6 x 74.9 cm)
Collection of Mr. and Mrs.
Julius Rosenwald II

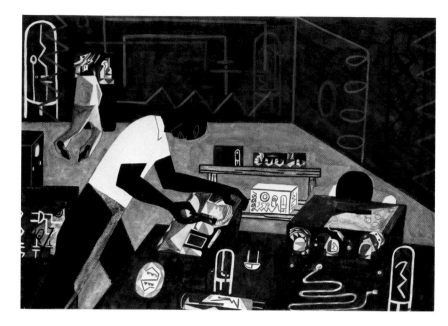

Stuart Davis
American, 1894–1964
Pennsylvania
1946
Pencil on paper
14 x 12½″ (35.6 x 31.8 cm)
Collection of Mr. and Mrs.
Meyer P. Potamkin

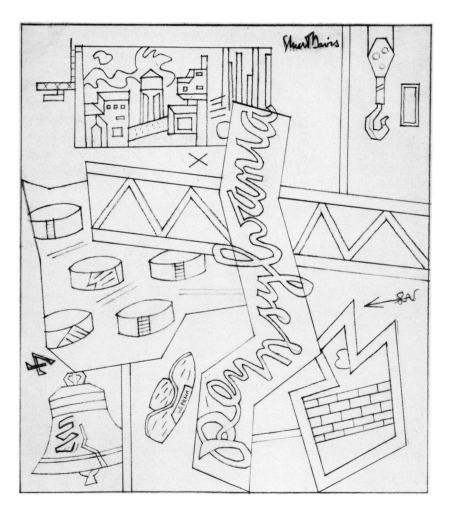

Philip Evergood
American, 1901–1973
Croquet
c. 1951
Oil on canvas
49½ x 29½" (125.7 x 74.9 cm)
Private collection

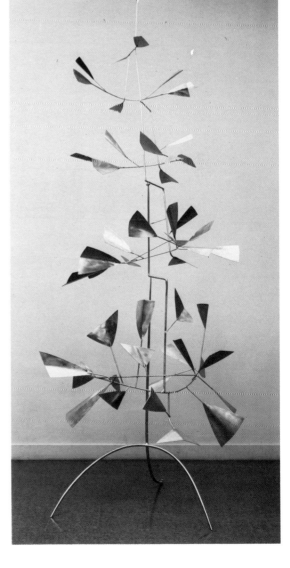

George Rickey
American, born 1907
Vine
1962
Stainless steel
Height 8½' (2.6 m)
Collection of Hope Byer

Charles Burchfield
American, 1893–1967
Queen Anne's Lace
1946
Watercolor on paper
32 x 25½″ (81.3 x 64.8 cm)
Collection of Mr. and Mrs.
J. Welles Henderson

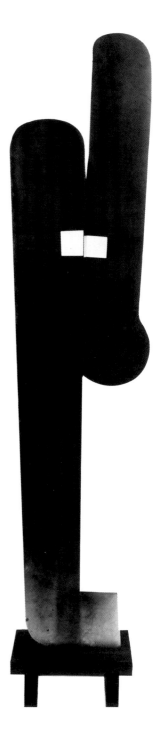

Isamu Noguchi
American, born 1904
Thanatos
1958
Aluminum
Height 86½″ (219.7 cm)
Collection of Mr. and Mrs.
Daniel W. Dietrich II

Milton Avery
American, 1893–1965
Man and Wife
1944
Oil on canvas
24 x 18″ (61 x 45.7 cm)
Collection of Mr. and Mrs.
Irving R. Segal

Milton Avery
American, 1893–1965
Farmyard
1959
Opaque watercolor on paper
17 x 22½″ (43.2 x 57.2 cm)
Private collection

Alexander Calder
American, 1898–1976
The Black Palm
1953
Ink, watercolor, and gouache
on paper
29½ x 41¼″ (74.9 x 104.8 cm)
(sight)
Private collection

Morris Graves
American, born 1910
Fox with Chalice
1943
Opaque watercolor on paper
21 x 30¼″ (53.3 x 76.8 cm)
(sight)
Private collection

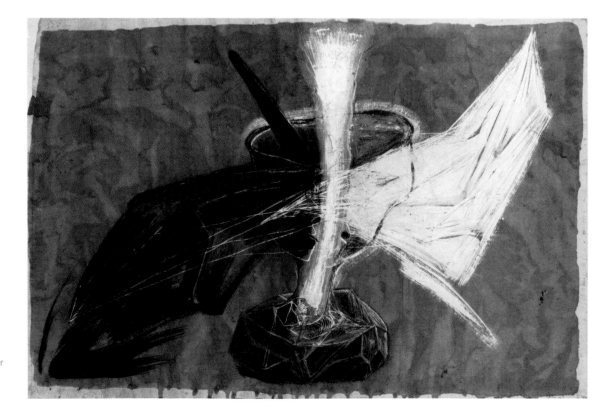

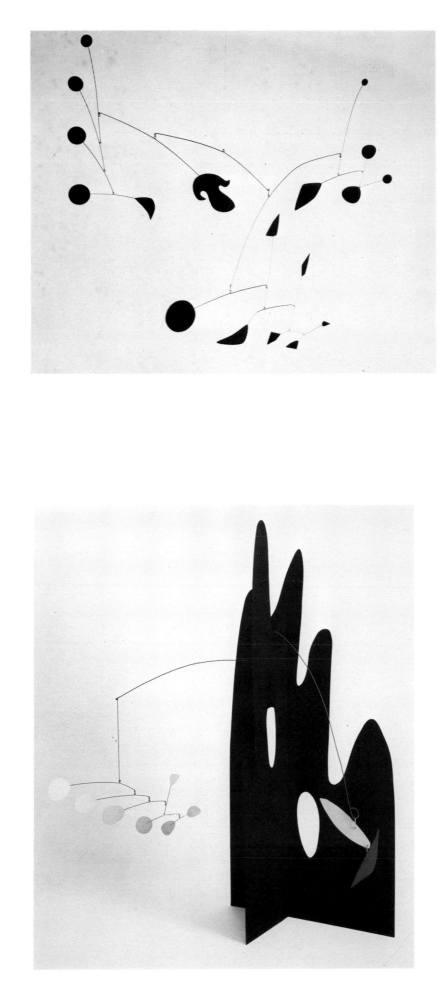

Alexander Calder
American, 1898–1976
Black: Flowers in 17
1959
Painted steel
Height 40″ (101.6 cm)
Private collection

Alexander Calder
American, 1898–1976
*Crag with Yellow-Red
Counterweight*
1974
Painted sheet metal and
steel wire
Height 62¼″ (158.1 cm)
Private collection

Joseph Cornell
American, 1903–1972
*L'Académie Impériale des
Sciences (Soap Bubble
Variant)*
c. 1956
Construction
9 x 14³⁄₁₆ x 3⅞"
(22.9 x 36 x 9.8 cm)
Private collection

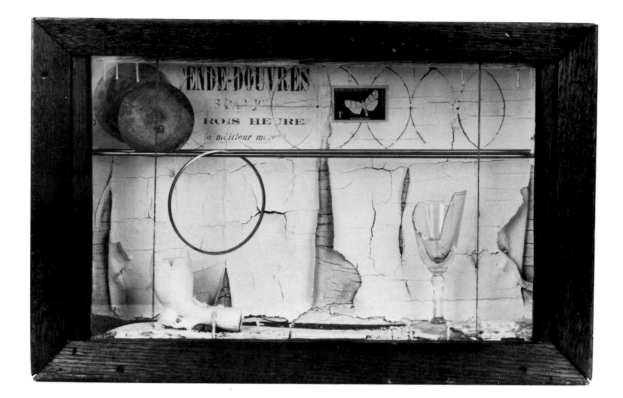

Joseph Cornell
American, 1903–1972
Dovecote
1953–55
Construction
10½ x 5¾ x 3¾"
(26.7 x 14.6 x 9.5 cm)
Private collection

Joseph Cornell
American, 1903–1972
*Hôtel de l'Étoile (Hotel
Andromeda)*
c. 1954
Construction
15⅝ x 9⅛ x 3¼" (39.7 x 23.2 x
8.3 cm)
Private collection

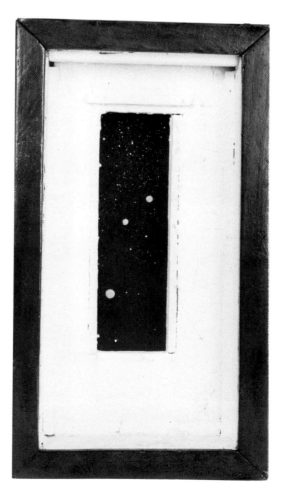 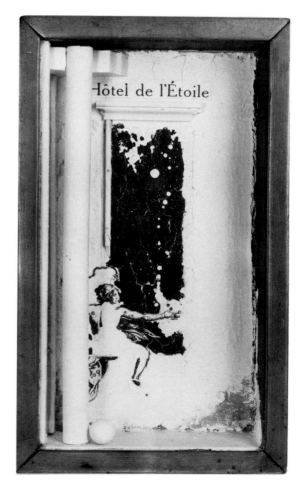

Joseph Cornell
American, 1903–1972
The Wanderer
1951–53
Construction
12⅞ x 9 1/16 x 4⅝″
(32.7 x 23 x 11.7 cm)
Private collection

Joseph Cornell
American, 1903–1972
Pocket Object
1940
Construction
5⅛ x 4⅛ x ⅞″
(13 x 10.5 x 2.2 cm)
Private collection

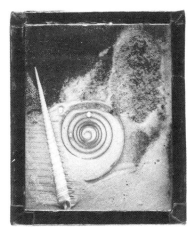

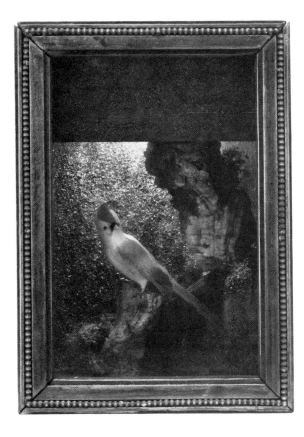

Josoph Cornell
American, 1903–1972
Celestial Navigation
1956–59
Construction
12⅛ x 17 3/16 x 3¾″
(30.8 x 43.7 x 9.5 cm)
Private collection

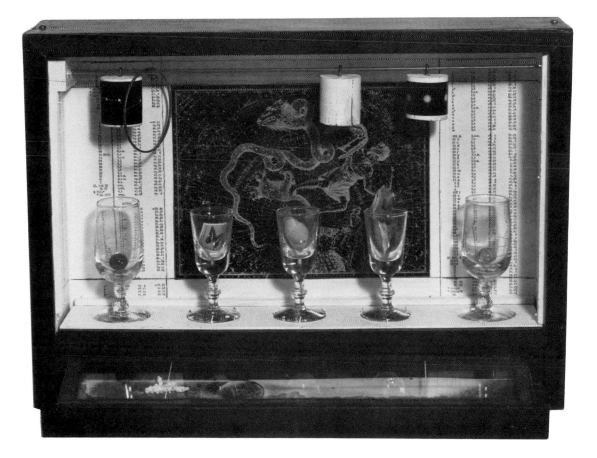

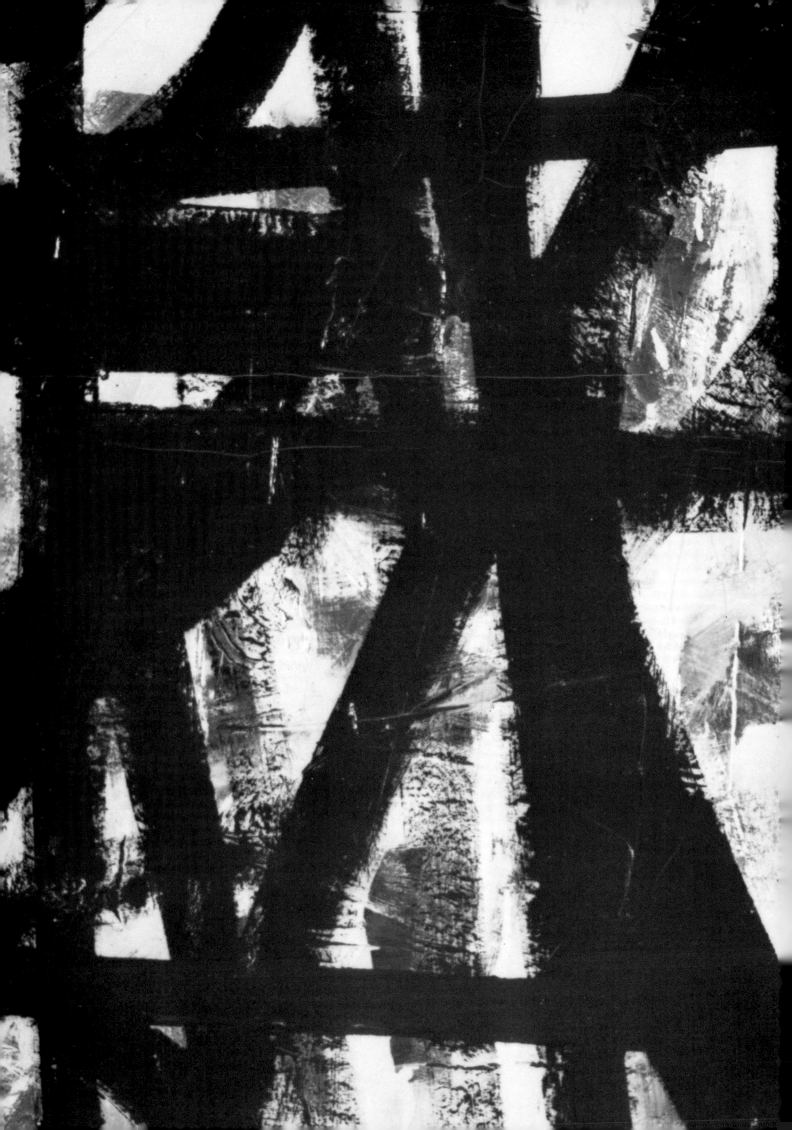

ABSTRACT EXPRESSIONIST GENERATION

During the last years of World War II, many European artists settled temporarily in the United States and the center of the art world shifted away from Paris toward New York. With the horrors of two wars close behind them and the possibilities apparently bright for the new world, a generation of artists emerged in New York and California and forged what Irving Sandler has called "the triumph of American painting."*

Artists at the time confronted the devastating legacy of world war: the feeling that fundamental aspects of life had lost their meaning. With great personal commitment and faith in the power of art, the painters who would become known as the Abstract Expressionists turned to the formal elements of art and looked there for value. Drawing upon Surrealism and aspects of early European modernism, they first explored the richness of myth and primitive symbolism. As time passed, their works grew increasingly abstract and spiritual in character and the process of painting itself often became their implicit subject. Jackson Pollock's linear all-over action painting, Hans Hofmann's push-pull color relationships, Willem de Kooning's sensual abstractions of flesh and landscape, Franz Kline's and Mark Tobey's differently calligraphic brushstrokes, Mark Rothko's hovering colors, and Barnett Newman's "zips" were intensely personal responses to the artists' explorations of the possibilities and limitations of their mediums. David Smith, Louise Bourgeois, and Richard Stankiewicz took ideas from Surrealism and Constructivism and, using new mediums, created abstract forms that similarly expanded the definition of sculpture. Artists of the New York school and their counterparts across the country gained attention for the immediacy and expressive power of their paintings and for their intense, romantic involvement with the creation of works of art.

*Irving Sandler, *The Triumph of American Painting* (New York, 1970).

Adolph Gottlieb
Armature (detail)

Robert Motherwell
American, born 1915
Spanish Prison
1943–44
Oil on canvas
52¼ x 42¼"
(132.7 x 107.3 cm)
Collection of H. Gates Lloyd

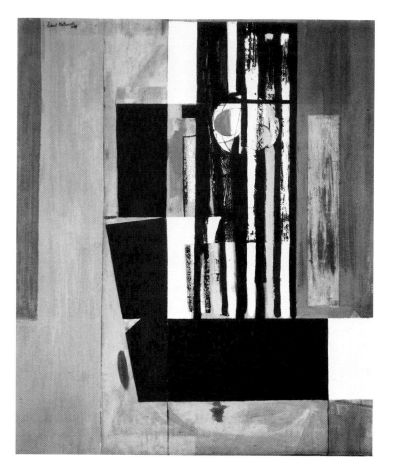

Robert Motherwell
American, born 1915
Open No. 92 (The Blue Wall)
1969
Acrylic on canvas
72 x 42" (182.9 x 106.7 cm)
Anonymous promised gift to
the Philadelphia Museum of Art

William Baziotes
American, 1912–1963
Star Figure
1948
Oil on canvas
23 x 19″ (58.4 x 48.3 cm)
Collection of Mr. and Mrs.
Meyer P. Potamkin

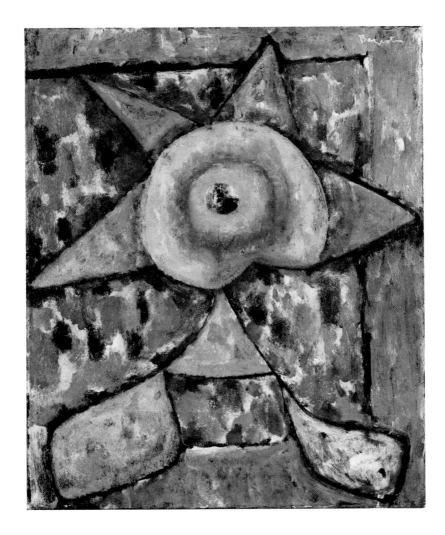

William Baziotes
American, 1912–1963
Shadow
1958
Watercolor and pencil on
paper
14⅝ x 18⅝″ (37.1 x 47.3 cm)
Private collection

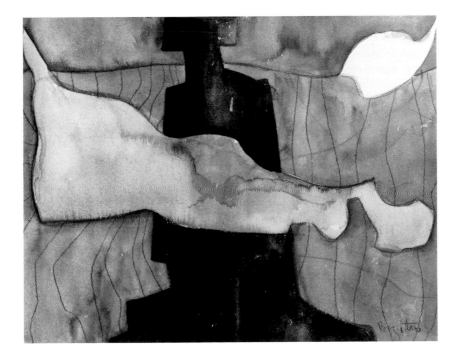

Louise Nevelson
American, born Russia, 1900
Royal Winds I
1960
Painted wood
Height 83" (210.8 cm)
Private collection

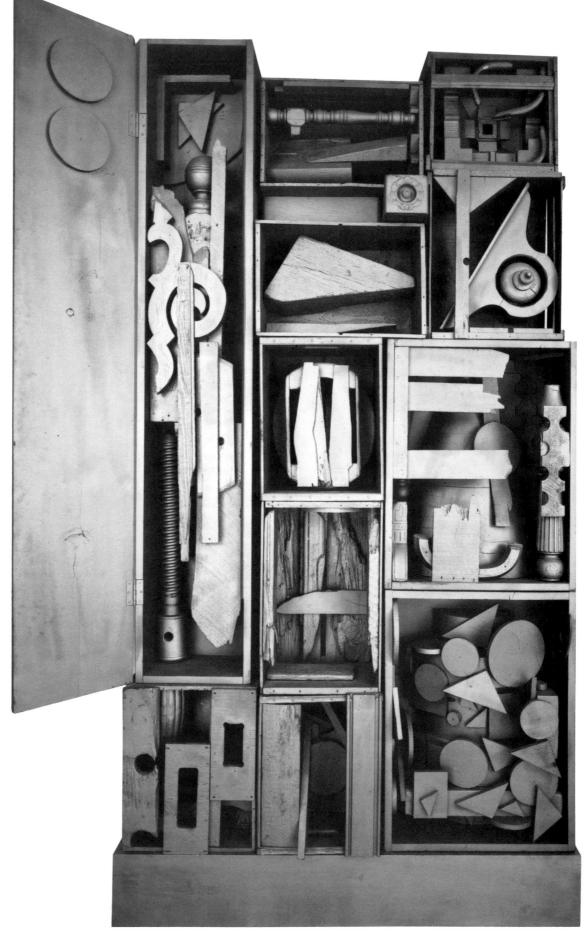

Pierre Alechinsky
Belgian, born 1927
Maternal Fiber
1967
Acrylic on canvas
63½ x 51" (161.3 x 129.5 cm)
Collection of Mr. and Mrs.
Melvin Golder

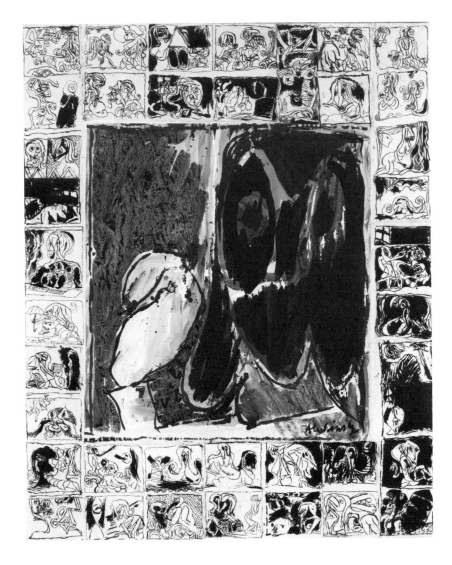

Richard Stankiewicz
American, 1922–1983
Untitled
c. 1960
Welded steel
Height 16½" (41.9 cm)
Collection of Mr. and Mrs.
Harold P. Starr

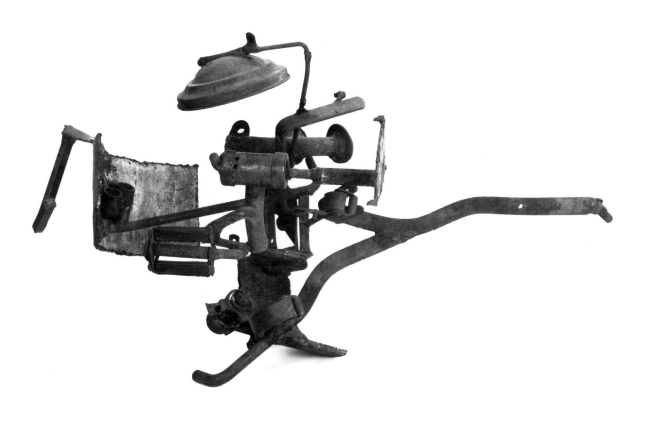

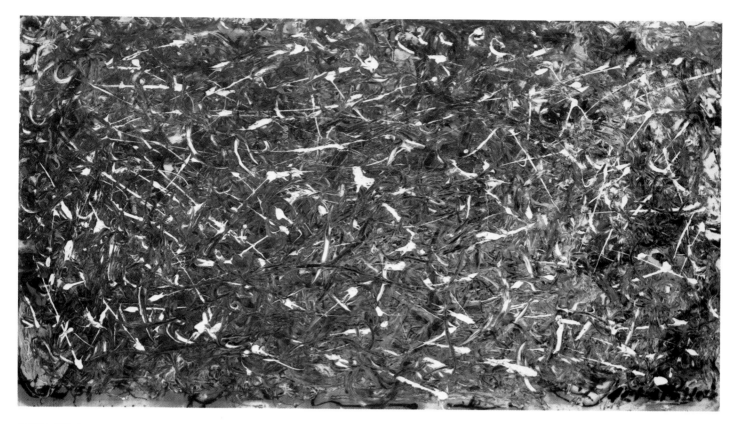

Jackson Pollock
American, 1912–1956
No. 28, 1951
1951
Oil on canvas
30⅛ x 54⅛" (76.5 x 137.5 cm)
Private collection

Jackson Pollock
American, 1912–1956
Untitled
1951
Ink (black and colored) on
paper
24½ x 34" (62.2 x 86.4 cm)
Private collection

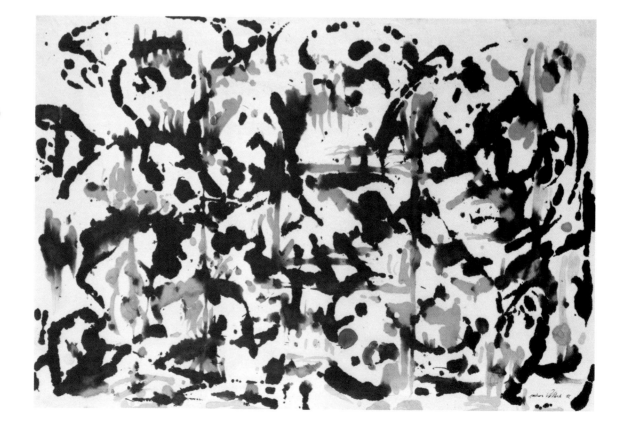

Hans Hofmann
American, born Germany,
1880–1966
Nocturne
1952
Oil on canvas
60 x 48″ (152.4 x 121.9 cm)
Private collection

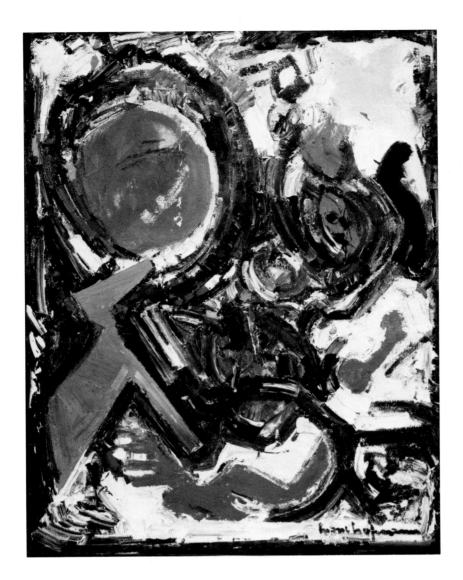

Hans Hofmann
American, born Germany,
1880–1966
Reflection
1957
Oil on canvas
48 x 36″ (121.9 x 91.4 cm)
Private collection

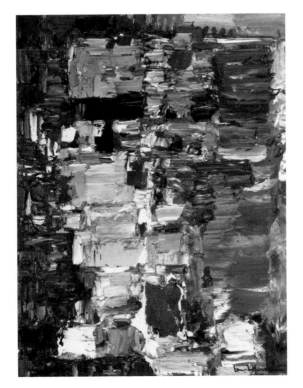

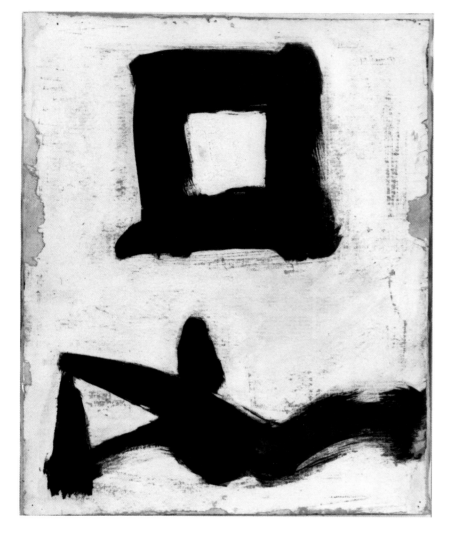

Franz Kline
American, 1910–1962
Study for "Leda"
c. 1950
Oil on paper
11 x 9" (27.9 x 22.9 cm)
Collection of Dr. and Mrs.
William Wolgin

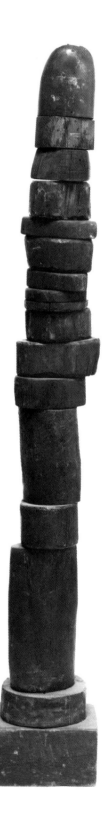

Louise Bourgeois
American, born France, 1911
Untitled
c. 1953
Wood
Height 60" (152.4 cm)
Collection of Helen Herrick
and Milton Brutten

Mark Tobey
American, 1890–1976
Celestial Drift
1969
Opaque watercolor on paper
mounted on canvas
40 x 27⅞″ (101.6 x 70.8 cm)
Collection of Marvin Lundy

Sam Francis
American, born 1923
Untitled
1952
Watercolor on paper
17½ x 14″ (44.5 x 35.6 cm)
Private collection

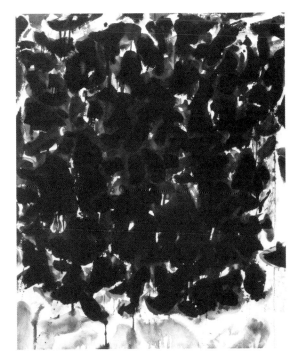

Willem de Kooning
American, born
The Netherlands, 1904
Untitled I
1980
Oil on canvas
80 x 70" (203.2 x 177.8 cm)
Private collection

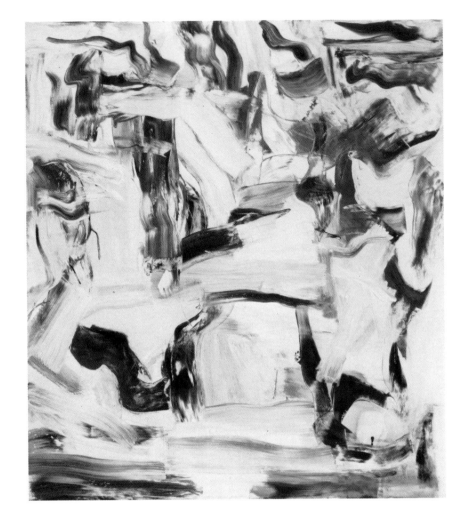

Willem de Kooning
American, born
The Netherlands, 1904
Untitled
c. 1970
Charcoal on vellum
22½ x 28½" (57.2 x 72.4 cm)
Collection of Mr. and Mrs.
David Pincus

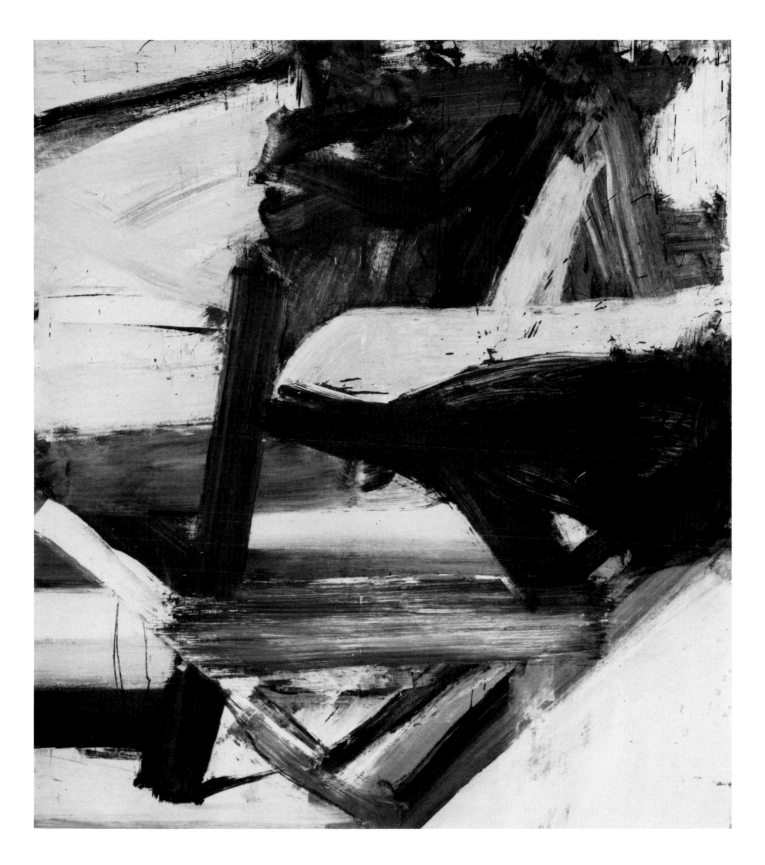

Willem de Kooning
American, born
The Netherlands, 1904
Bolton Landing
1957
Oil on canvas
83¾ x 74″ (212.7 x 188 cm)
Collection of Norman and Irma
Braman

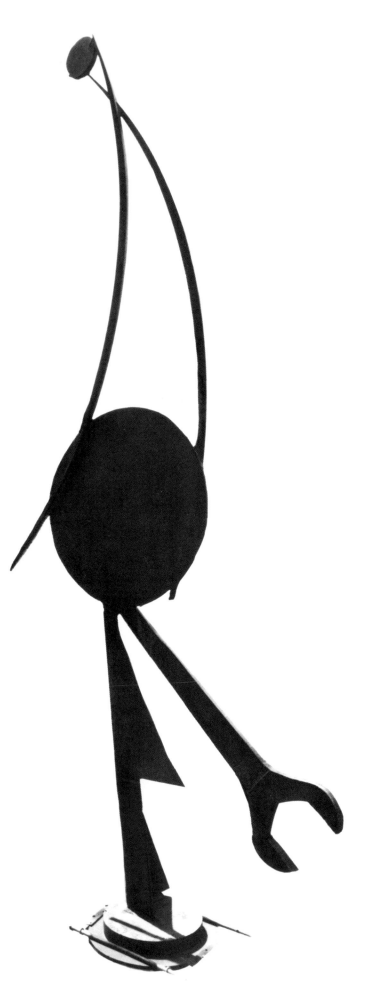

David Smith
American, 1906–1965
Voltri Bolton I
1962
Steel
Height 9′4¾″ (2.9 m)
Collection of Dr. and Mrs. Paul
Todd Makler

Mark Rothko
American, born Rus
1903–1970
Untitled
1953
Oil on canvas
74 x 61″ (188 x 154.9
Collection of Mr. and
Robert Kardon

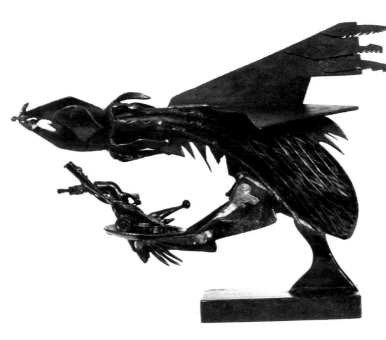

David Smith
American, 1906–1965
False Piece Specter
1945
Steel and bronze
Height 21½″ (54.6 cm)
Private collection

Mark Rothko
American, born Russia,
1903–1970
Black over Deep Red
1957
Oil on canvas
69 x 54″ (175.3 x 137.2
Private collection

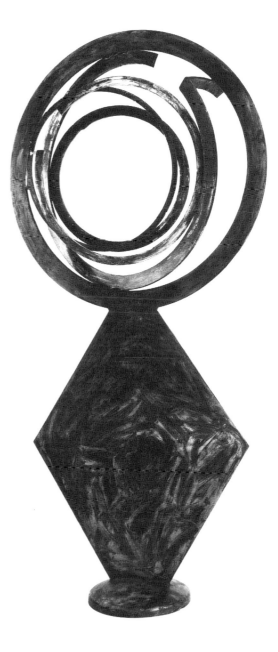

David Smith
American, 1906–1965
Noland's Blues
1961–62
Painted steel
Height 8′3⅛″ (2.5 m)
Collection of Mr. and Mrs.
Harold P. Starr

I n reaction to the loose, expressive brush-stroke and intensely felt content of much Abstract Expressionist work, artists of the second generation New York school began to formalize the gesture of painting. Some stained directly into the canvas or painted areas of undifferentiated color within severely demarcated edges, gaining the name of color field painters. In the modernist tradition, these artists were concerned with purely pictorial questions. Their "veils" and stripes simultaneously asserted the primacy of the picture plane—the existence of paint on a two-dimensional surface—and challenged the limits that definition imposed. Helen Frankenthaler's poured, fluid forms, Kenneth Noland's bold circles and diagonals, and Frank Stella's simplified formats and (later) shaped canvases abrogated conventional illusionism and focused attention on the dynamics of pure color.

Painters have continued to explore the expressive possibilities of their medium. Cy Twombly stresses the quality of isolated line and its affinity to writing; Howard Hodgkin visually and metaphorically blurs the boundary between an image and its frame; Warren Rohrer paints seemingly hovering surfaces of subtly shifting colors; and Alan Shields cuts shapes out of canvas and exhibits the result, unframed, as an abstracted and decorative object itself. The continued evolution of the work begun after Abstract Expressionism and the defiance of the limitations inherent in representation have increasingly confounded the distinction between painting and sculpture: the canvas has been shaped, cut into, and removed from the support of the stretcher or the sanctity of the frame. "Paintings" incorporate objects and extend outward in three dimensions.

ABSTRACTION

Cy Twombly
Untitled (detail)

Helen Frankenthaler
American, born 1928
Brown Bird
1959
Oil on canvas
48 x 50″ (121.9 x 127 cm)
Collection of Helen and Jack
Bershad

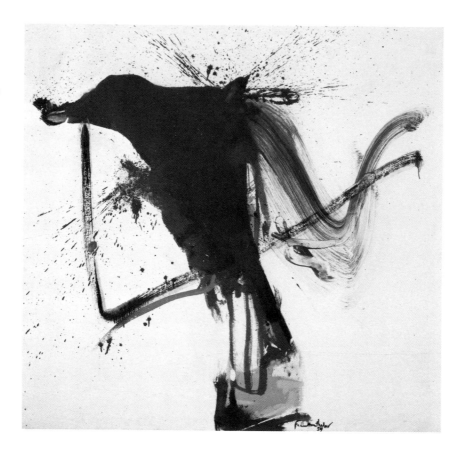

Helen Frankenthaler
American, born 1928
Frontispiece
1968
Acrylic on paper
40 x 34″ (101.6 x 86.4 cm)
Collection of Mr. and Mrs.
Dennis Alter

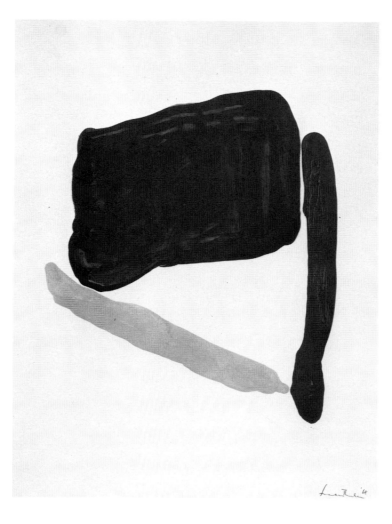

Cy Twombly
American, born 1928
Untitled
1970
Oil and crayon on canvas
63½ x 77½"
(161.3 x 196.9 cm)
Collection of Mr. and Mrs.
Gilbert W. Harrison

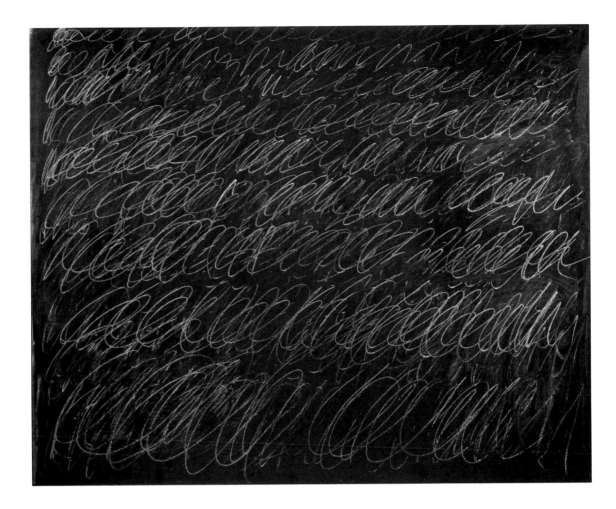

Cy Twombly
American, born 1928
Untitled
1965
Pencil and crayon on paper
26½ x 34" (67.3 x 86.4 cm)
Private collection

Kenneth Noland
American, born 1924
Fault Slant
1966
Acrylic on canvas
94 x 23" (238.8 x 58.4 cm)
Collection of Mr. and Mrs.
J. Welles Henderson

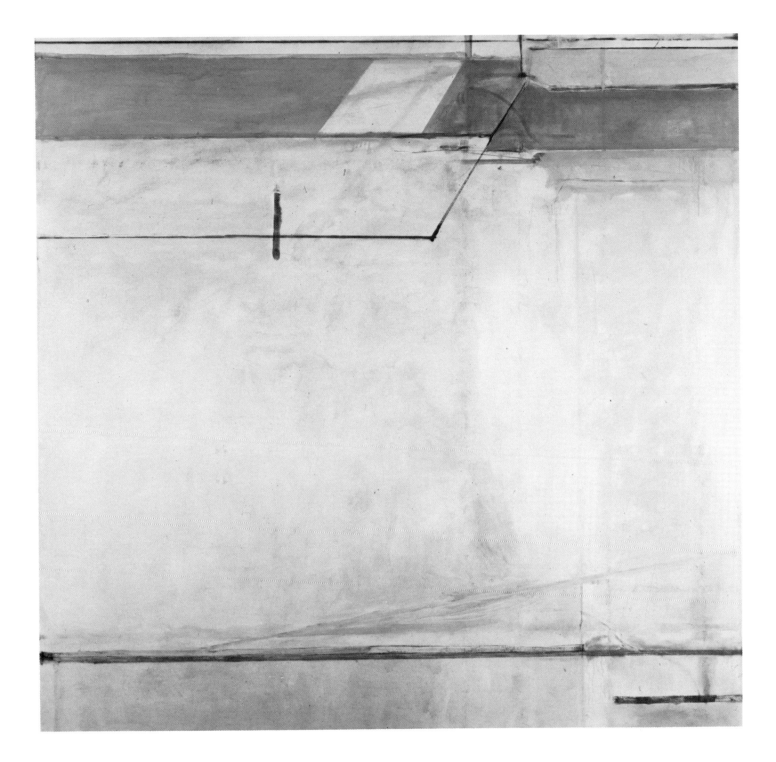

Richard Diebenkorn
American, born 1922
Ocean Park No. 63
1973
Oil on canvas
81 x 81″ (205.7 x 205.7 cm)
Private collection

Edna Andrade
American, born 1917
Ebbtide
1976
Acrylic on canvas
50 x 50″ (127 x 127 cm)
Collection of Mr. and Mrs.
James Nelson Kise

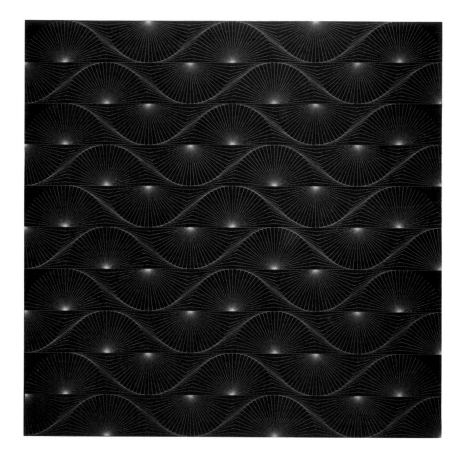

John McLaughlin
American, 1898–1976
No. 1, 1973
1973
Oil on canvas (two sections)
Each 60 x 48″
(152.4 x 121.9 cm)
Collection of Mr. and Mrs.
Leonard F. Yablon and
daughters

Elizabeth Murray
American, born 1940
Untitled
1975
Charcoal on paper
46 x 42″ (116.8 x 106.7 cm)
Promised gift of Marion Stroud
Swingle to the Philadelphia
Museum of Art

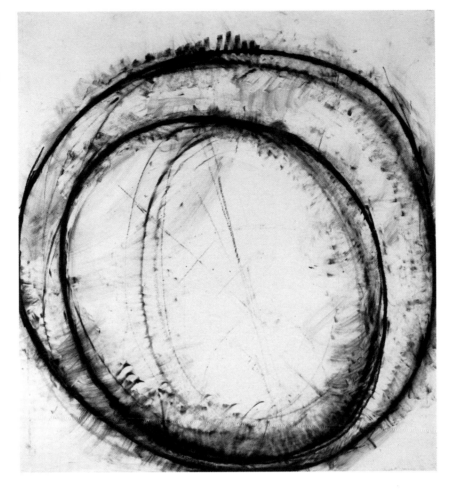

John Dowell
American, born 1941
Sound Power with Time
1981
Watercolor and india ink on
paper
30 x 22½″ (76.2 x 57.2 cm)
Collection of James D.
Crawford and Judith N. Dean

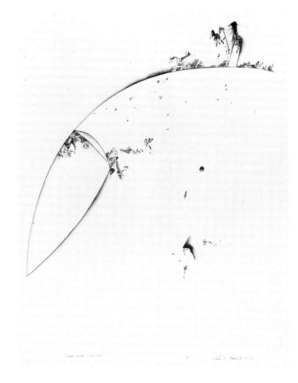

Howard Hodgkin
British, born 1932
In a Hotel Bedroom
1985–86
Oil on wood
28⅜ x 29⅜" (72.1 x 74.6 cm)
Collection of Mr. and Mrs.
Keith L. Sachs

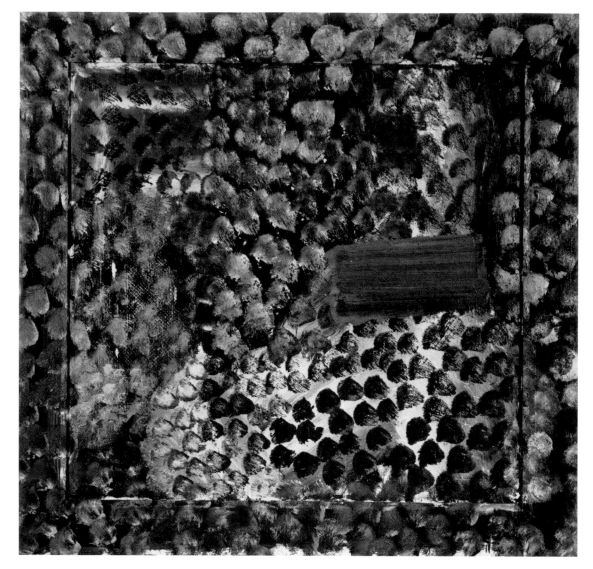

Alan Shields
American, born 1944
Very Fatt
1978
Acrylic on unstretched canvas
68 x 58½" (172.7 x 148.6 cm)
Collection of the Honorable
Herbert A. Fogel

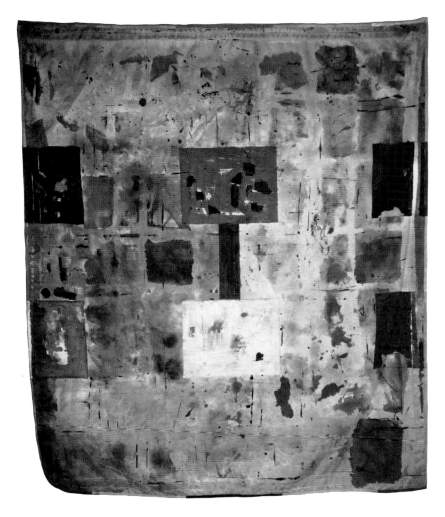

Porfirio Di Donna
American, 1942–1986
Untitled
1979
Gouache, crayon, and
charcoal on paper
41⅝ x 29½" (105.7 x 74.9 cm)
Collection of Helen Herrick
and Milton Brutten

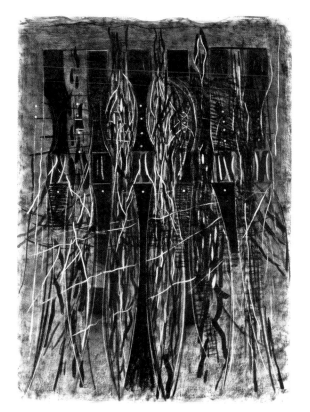

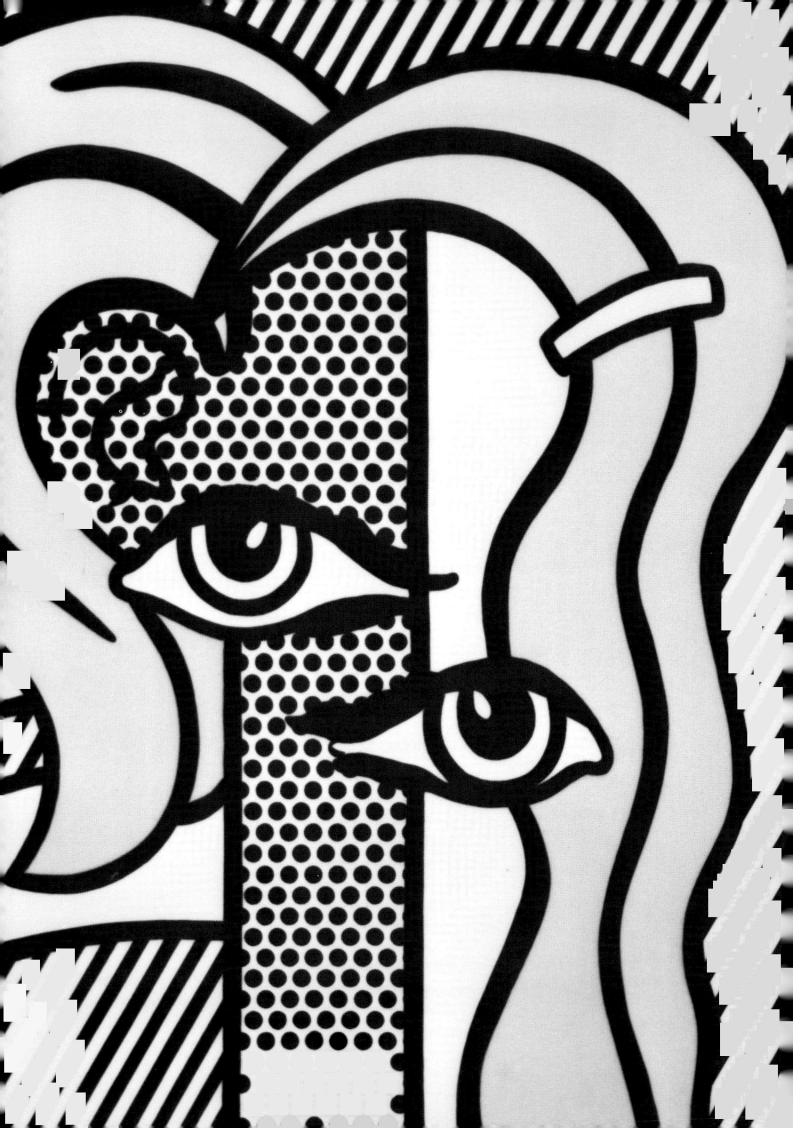

POP ART

Pop art originated in Britain in the late 1950s, its lively and irreverent attitudes catching on rapidly across the Atlantic. Robert Rauschenberg's oft-quoted statement stands as a paradigm for this period: "Painting relates to both art and life. Neither can be made. (I try to act in that gap between the two.)"* Partly in response to the abstraction and expressive emotion of the 1940s and 1950s, artists began to turn back to recognizable subject matter, appropriating commercial imagery and popular culture in ways that bridged the "gap" between art and life.

In their attempt to explore the meanings of modern symbols, artists borrowed and reworked imagery from advertisements, billboards, comic books, movies, and television. Their choice and juxtapositions of images were pointed and frequently ironic or humorous. Works explored the nature of and differentiation between "fine" art and "low" culture. Andy Warhol's silkscreen process, Roy Lichtenstein's larger-than-life Ben Day dots, and Claes Oldenburg's enlargement of ordinary objects into monuments stressed the apparent "objectivity" of their work, their distance from the expressionism of the previous generation, and the numbing effect of duplication and reproduction in American culture. The presentation of oversized Brillo boxes, serried Campbell Soup cans, and the faces of glamorous public figures as "art" caught Americans off guard and forced them to confront their chosen icons and idols. Pop art had a powerful impact, and its approach to subject matter continues to be relevant today, although the work of many artists who originally defined the movement has evolved into a variety of new modes.

*New York, The Museum of Modern Art, *Sixteen Americans* (1959), p. 58.

Roy Lichtenstein
Sitting Pretty (detail)

Robert Rauschenberg
American, born 1925
*Drawing III for 700 Birthday of
Dante*
1965
Silkscreen, gouache, water-
color, and pencil on two
cardboard panels
Each 15 x 31″ (38.1 x 78.7 cm)
Private collection

Jasper Johns
American, born 1930
Flag
1971
Encaustic and collage on
canvas
26 x 17" (66 x 43.2 cm)
Private collection

Ed Ruscha
American, born 1937
Egg
1970
Gunpowder on paper
11⅝ x 29″ (29.5 x 73.7 cm) (sight)
Collection of Jack and Muriel
Wolgin

Ed Ruscha
American, born 1937
Securing the Last Letter
1964
Oil on canvas
59 x 55″ (149.9 x 139.7 cm)
Collection of Ed Sabol

Andy Warhol
American, born 1928
Self-Portrait (Double)
1966
Acrylic and silkscreen on two
canvases
Each 22 x 22″ (55.9 x 55.9 cm)
Private collection

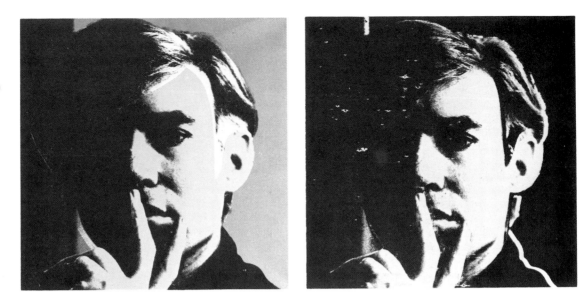

Andy Warhol
American, born 1928
Electric Chair
1964
Silkscreen on canvas (four
sections)
Each 22 x 28″ (55.9 x 71.1 cm)
Collection of Mr. and Mrs.
David Pincus

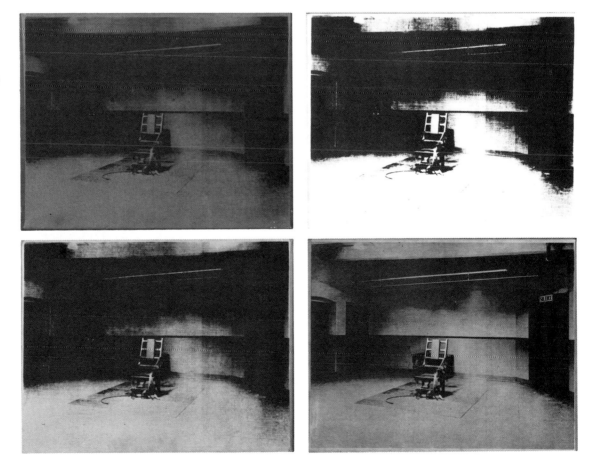

Roy Lichtenstein
American, born 1923
Sitting Pretty
1978
Oil and Magna on canvas
70 x 50″ (177.8 x 127 cm)
Private collection

Roy Lichtenstein
American, born 1923
Glass I
1977
Painted bronze
22⅛ x 12¾ x 7⅛″ (56.2 x 32.4
x 18.1 cm)
Collection of Mr. and Mrs.
Stanley C. Tuttleman

Roy Lichtenstein
American, born 1923
Guitar
1974
Oil and Magna on canvas
36 x 48″ (91.4 x 121.9 cm)
Collection of Suzanne and
Robert Morgan

Jim Dine
American, born 1935
*The Death at South
Kensington (October)*
1983
Oil on canvas with wood
60½ x 87½ x 17¾" (153.7 x
222.3 x 45.1 cm)
Collection of Eileen Rosenau

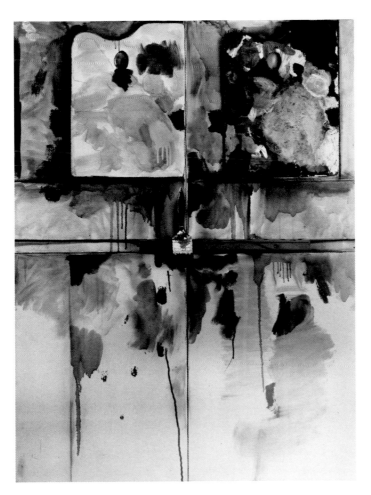

Jim Dine
American, born 1935
Portrait of Arman and Iliana
1964
Oil on canvas with palette,
wood strip, palette knife, and
brush
48 x 36" (121.9 x 91.4 cm)
Collection of Dr. and Mrs.
William Wolgin

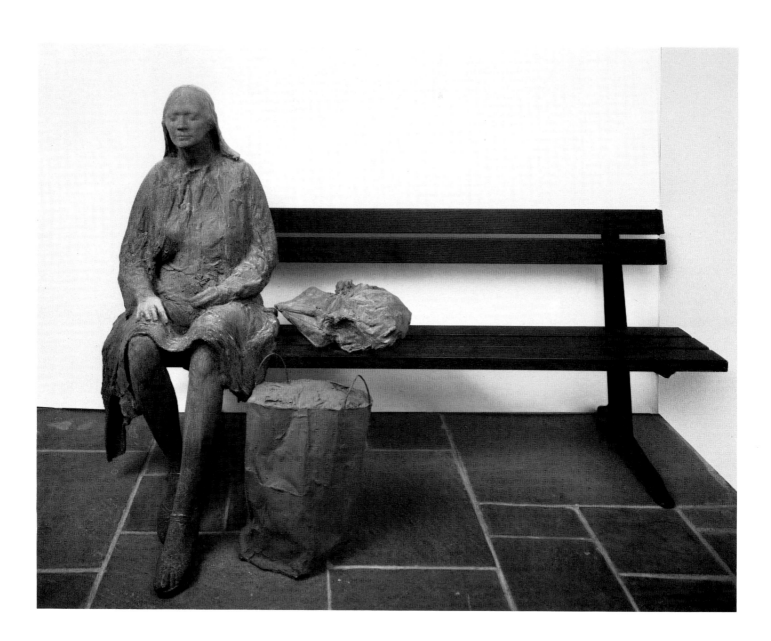

George Segal
American, born 1924
Blue Girl on Park Bench
1980
Painted plaster and aluminum
Height 51″ (129.5 cm)
Collection of Mr. and Mrs.
Melvin Golder

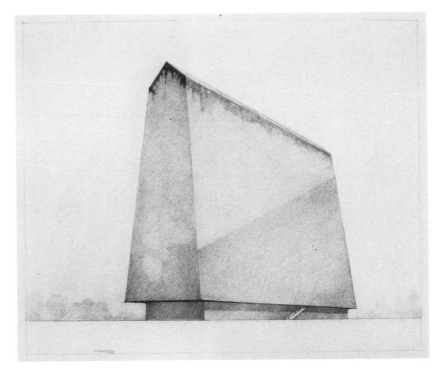

Claes Oldenburg
American, born Sweden, 1929
*Study for a Tomb Monument
to Louis Sullivan*
1969–71
Crayon and pencil on paper
21½ x 25″ (54.6 x 63.5 cm)
Promised gift of Marion Stroud
Swingle to the Philadelphia
Museum of Art

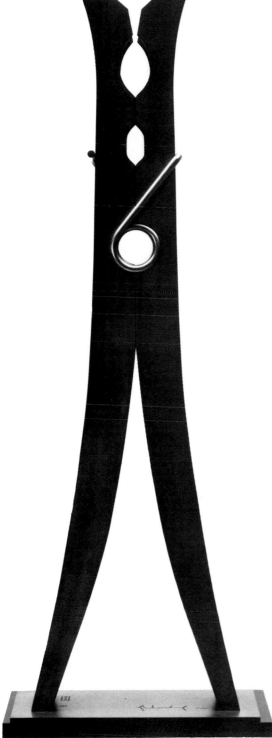

Claes Oldenburg
American, born Sweden, 1929
Clothespin—4
1974
Bronze and steel
Height 47¾″ (121.3 cm)
Collection of Jack and Muriel
Wolgin

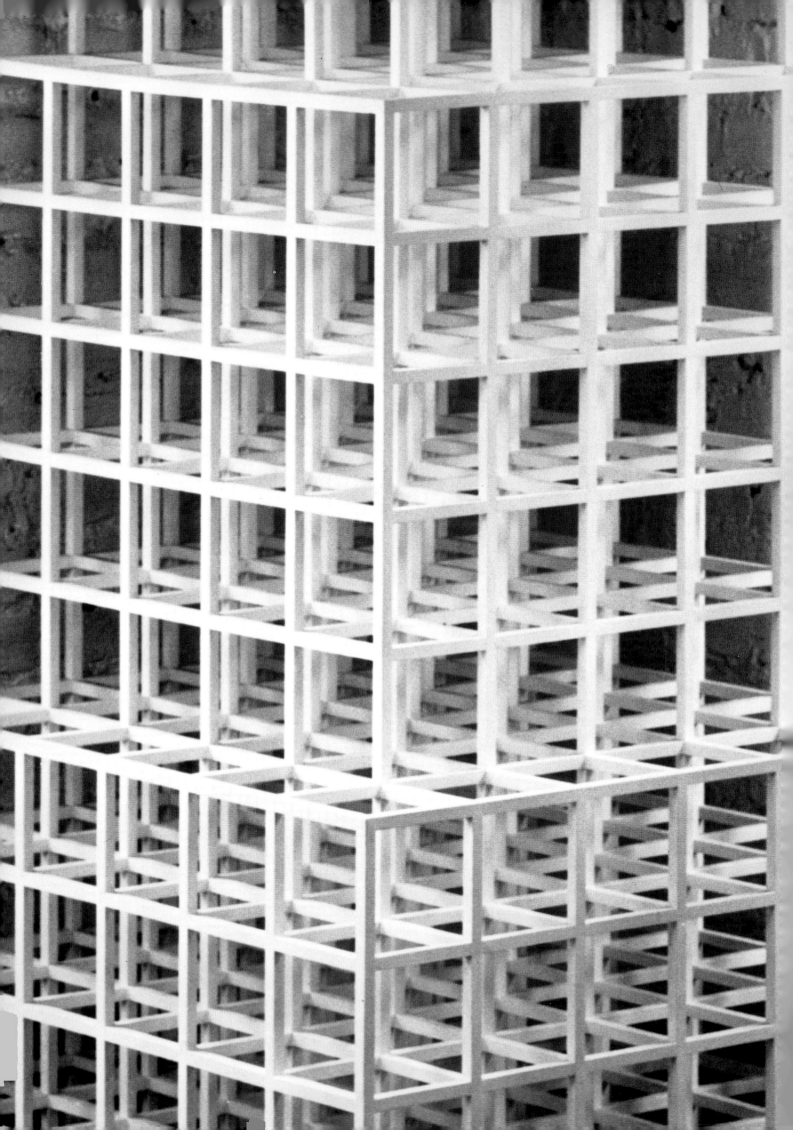

M

inimalism emerged during the 1960s. Initially, frustrated with the impassioned and personal characteristics of the art around them, artists searched for an austerely simplified, anonymous means of representation. Drawing inspiration from the refined images of hard-edge painting, especially those of Frank Stella, they reduced the elements of artistic language; focused on the formal terms of scale, color, and shape; and produced works characterized by severity, standardization, and impassive facades.

The transformation of the role of content and personal expression in works by these artists was reinforced by their suppression of allusion as well as all traces of the artist's hand at work. They turned to new mediums—including steel, plexiglass, plywood, glass, and fluorescent lights—which were chosen for their very lack of expressiveness or traditional associations with "art." The fact that these materials were frequently prefabricated and that the creation of a work of art could require only the artist's specifications suggested new possibilities and ramifications for their work. As emphasis was removed from the creative *act,* the meaning of a work was transferred to the idea (hence "conceptual art"); as the expressive potential of the medium was minimized, the interaction between the work and its surrounding space gained import. The physical and metaphysical realms available to the artist were thus expanded, despite an apparent poverty of means. Site-specific sculpture, earthworks, and happenings introduced the dimension of time and a freer exploration of space in their conception. What began as a protest against the "excesses" of contemporaneous schools resulted in the creation of works of sometimes grand extremes: monumental gestures in the landscape and fleeting performances documented only in photographs.

MINIMALISM, CONCEPTUAL ART, PERFORMANCE

Sol LeWitt
Corner Piece 1, 2, 3, 4, 5, 6
(detail)

Dan Flavin
American, born 1933
Untitled (to Barnett Newman)
1973
Fluorescent lights
Height 8' (2.4 m)
Collection of Eileen Rosenau

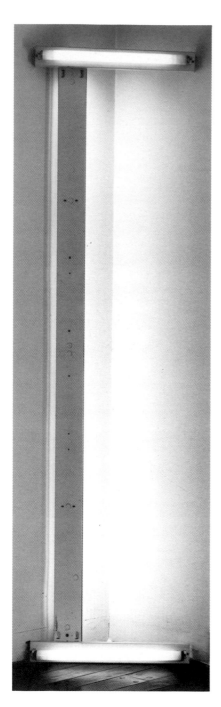

Chuck Fahlen
American, born 1939
Atomic Rock
1983–84
Painted aluminum and steel
Height 49" (124.5 cm)
Collection of Dr. and Mrs.
Louis Rossman

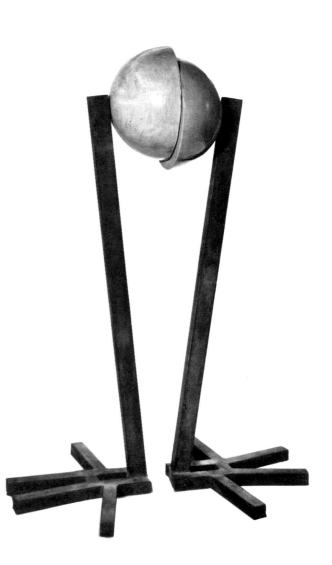

Donald Judd
American, born 1928
Untitled
1969
Galvanized iron and plexiglass
(ten sections)
Each 6 x 27 x 24″
(15.2 x 68.6 x 61 cm)
Collection of Mr. and Mrs.
Robert Kardon

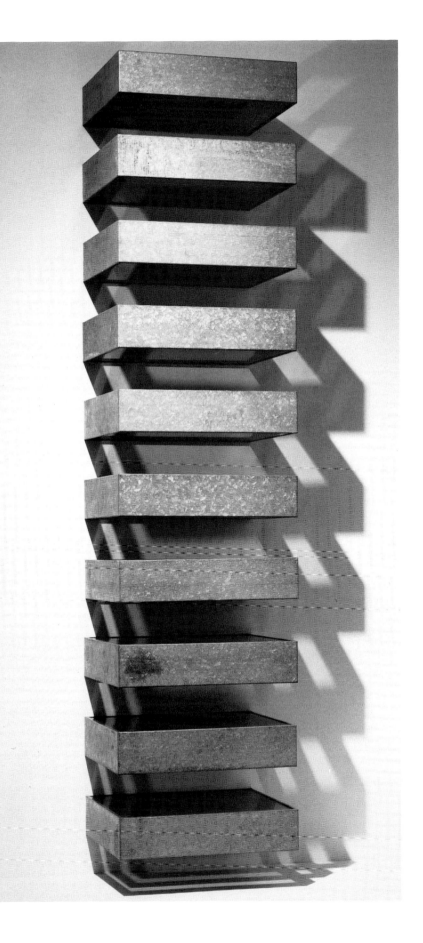

Agnes Martin
American, born Canada, 1912
Tundra
1967
Acrylic on canvas
72 x 72″ (182.9 x 182.9 cm)
Collection of Mr. and Mrs.
Daniel W. Dietrich II

Lynda Benglis
American, born 1941
Untitled
1966
Wax on Masonite
65 x 5 x 1½" (165.1 x 12.7
x 3.8 cm)
Collection of Helen Herrick
and Milton Brutten

Dorothea Rockburne
Canadian, born 1934
Velar-Combination Series
1978
Colored pencil on vellum
on rag board
43 x 33" (109.2 x 83.8 cm)
Private collection

Sol LeWitt
American, born 1928
Corner Piece 1, 2, 3, 4, 5, 6
1979
Painted wood
Height 99¼" (252.1 cm)
Private collection

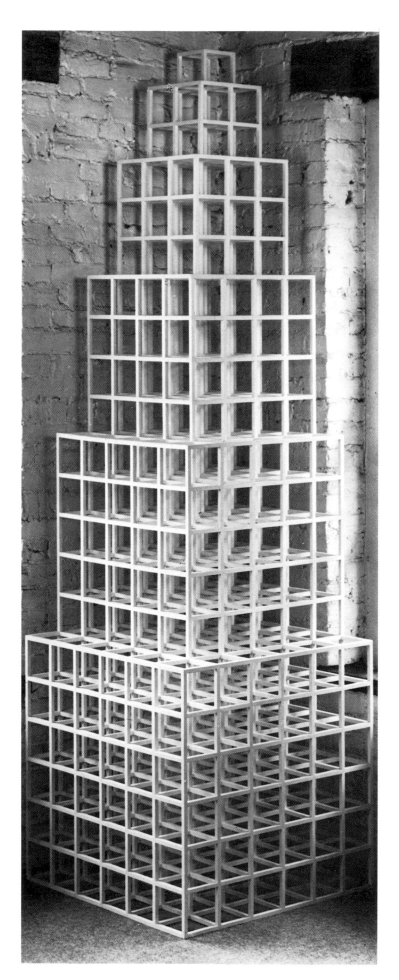

Vito Acconci
American, born 1940
*Note Sheet for "Views of a
Forced Landing"*
1974
Crayon, chalk, paint, photo-
graphs, and map fragment on
cardboard (twelve sections)
mounted on Masonite
Each 9¾ x 8½"
(24.8 x 21.6 cm)
Collection of Helen Herrick
and Milton Brutten

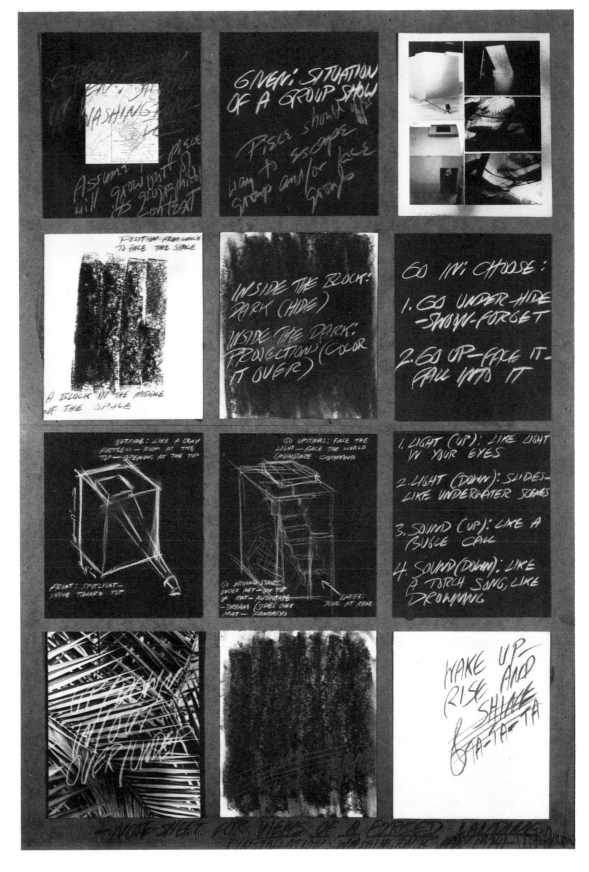

Christo
American, born Bulgaria, 1935
Abu Dhabi Mastaba
1978
Charcoal, watercolor, crayon,
and paint (?) on paper
64⅝ x 41¾" (164.1 x 106 cm)
Private collection

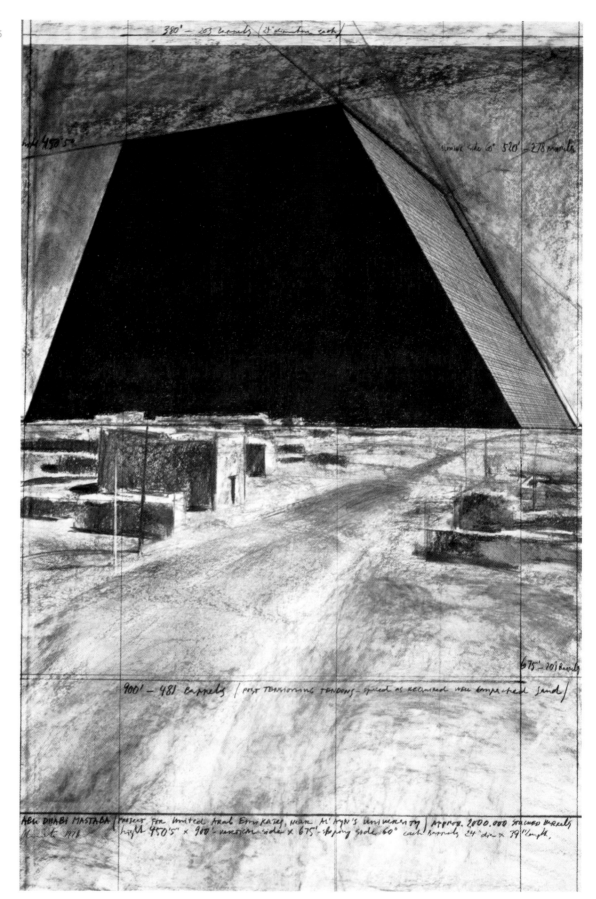

Robert Smithson
American, 1938–1973
Spiral of Cinnabar
1970
Pencil and crayon on paper
18⅞ x 23⅞" (47.9 x 60.6 cm)
Collection of Dr. and Mrs.
William Wolgin

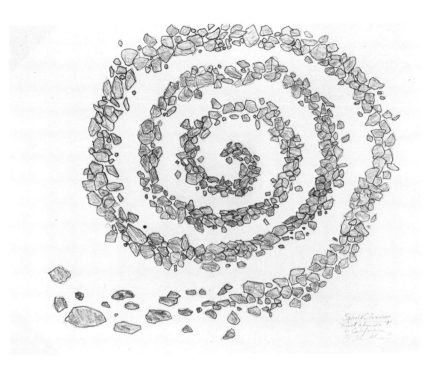

Richard Long
British, born 1945
Mud Finger Spiral
1984
Mud on paper
17 x 23⅞" (43.2 x 60.6 cm)
Collection of Helen Herrick
and Milton Brutten

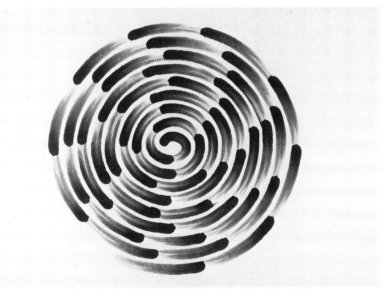

Christopher Wilmarth
American, born 1943
Baptiste (Longing) I
1983
Bronze and glass
40 x 51 x 6" (101.6 x 129.5 x
15.2 cm)
Private collection

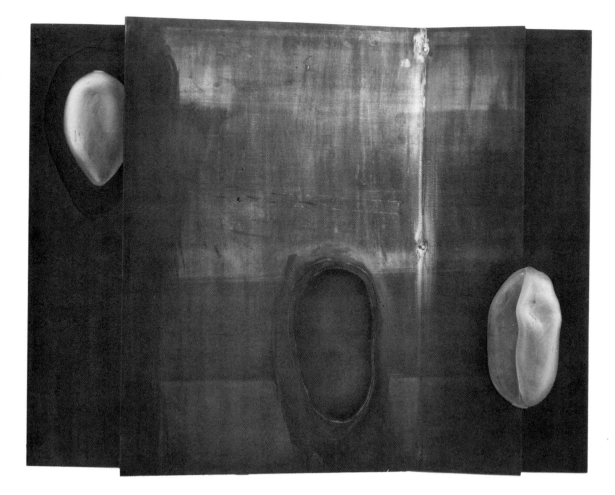

Alice Aycock
American, born 1946
Swirls after Leonardo
1982
Galvanized steel
Height 30" (76.2 cm)
Private collection

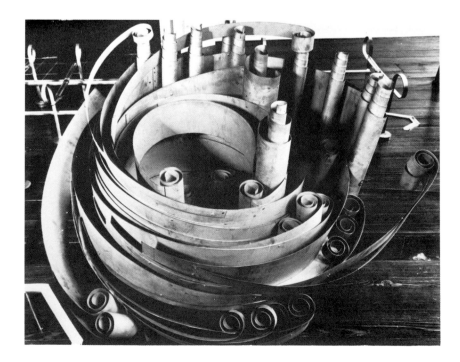

Alan Saret
American, born 1944
Reflected Aether
1982
Electrical wire
Height 48″ (121.9 cm)
Private collection

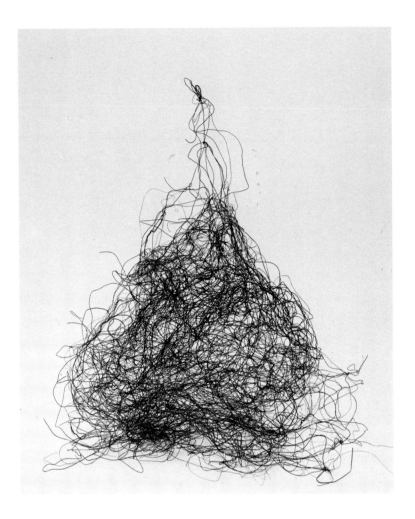

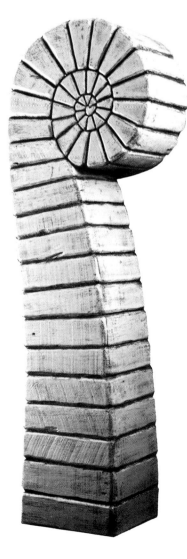

Brian Meunier
American, born 1954
Prehistory
1982–83
Painted wood
Height 79″ (200.7 cm)
Collection of Anne and
Matthew Hall

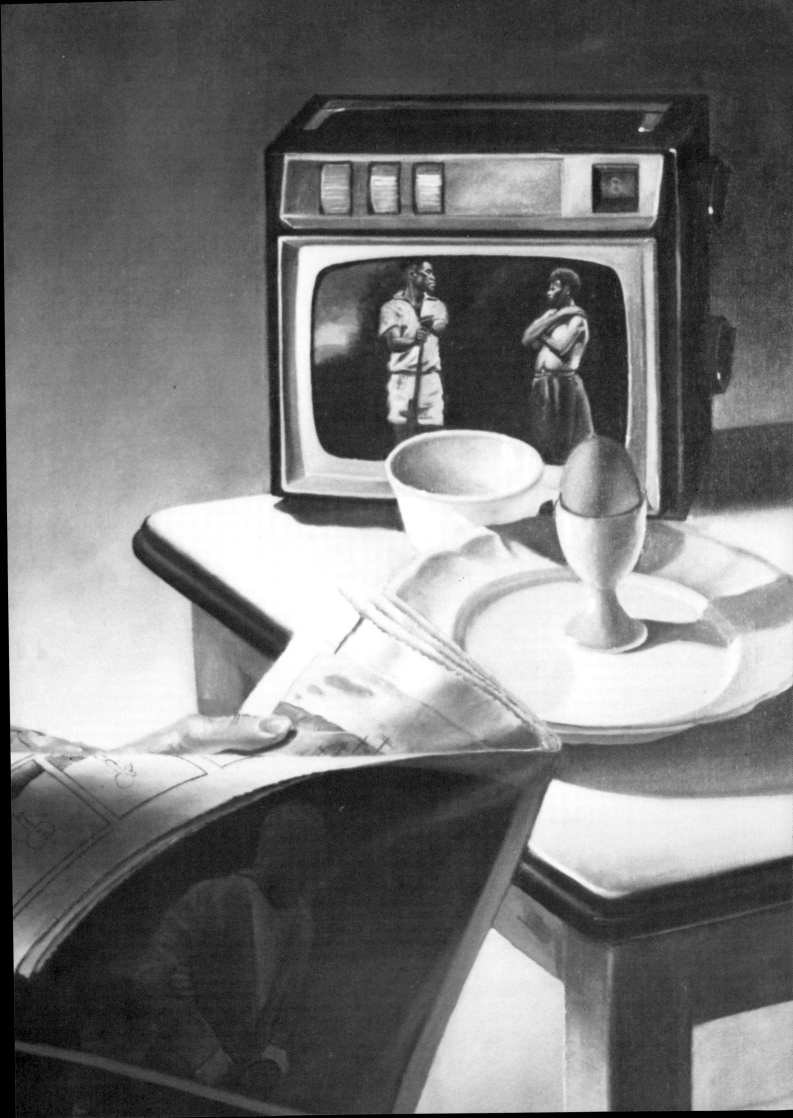

ASPECTS OF REALISM

However familiar in appearance, modes of realism in the 1960s and 1970s were informed by the lessons of abstraction. Many artists approached the representation of a figure or landscape from a background of modernism; others enlisted the technical means of photography. Painters such as Alfred Leslie, Sidney Goodman, and Alex Katz developed a contemporary iconography in their portrayal of interpersonal and psychological dramas. Philip Pearlstein, appropriating the artist's archetypal subject—the nude model—composed his canvases with a precision and tension associated with abstraction; his depersonalized, often truncated, figures are manipulated as forms and contrasted with the surfaces and spaces of their environments. Neil Welliver's groves of birch trees or snowy Maine hillsides are painted with richly overlapping strokes that mingle observation of nature with attention to the all-over treatment of the canvas surface. The work of Chuck Close exhibits a distinctly twentieth-century interest in process. His monumental portraits result from an intense preoccupation with the minute details that can be used to create illusion; he painstakingly constructs his image from a multitude of dots or layers of color. All the formats traditionally associated with realism—still life, landscape, "genre," even *vanitas* scenes—continued to be investigated but reflected a variety of approaches culled from sixty years of exploration of abstraction.

Alfred Leslie
Seven A.M. News (detail)

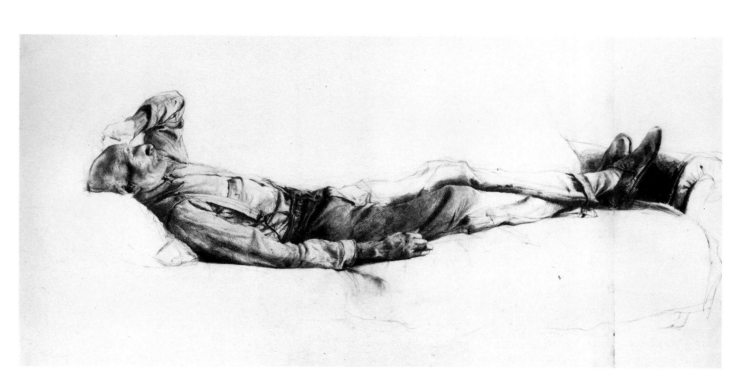

Andrew Wyeth
American, born 1917
*Reclining Figure (Study for
"Garret Room")*
1962
Pencil on paper
16 x 33″ (40.6 x 83.8 cm)
Private collection

John Moore
American, born 1941
Still Life with Marble Paper II
1979
Watercolor on paper
30 x 22″ (76.2 x 55.9 cm)
Collection of Dr. Charles W.
Nichols

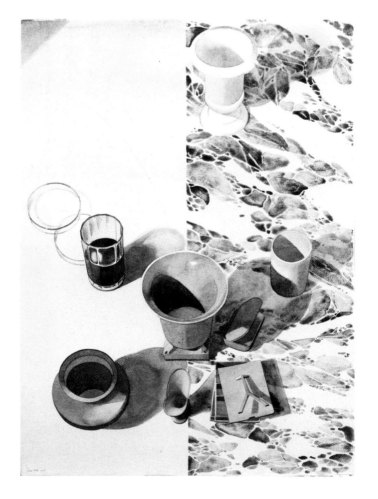

Robert Cottingham
American, born 1935
Dr. Gibson
1971
Oil on canvas
78 x 78" (198.1 x 198.1 cm)
Collection of Mr. and Mrs.
Robert Saligman

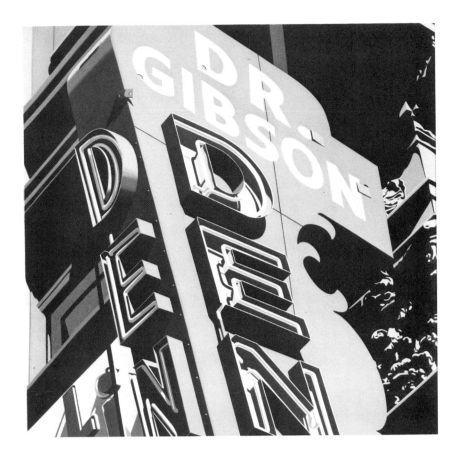

Neil Welliver
American, born 1929
Sun on Ledge
1985
Oil on canvas
60 x 60" (152.4 x 152.4 cm)
Collection of Mr. and Mrs.
Howard W. Bleiman

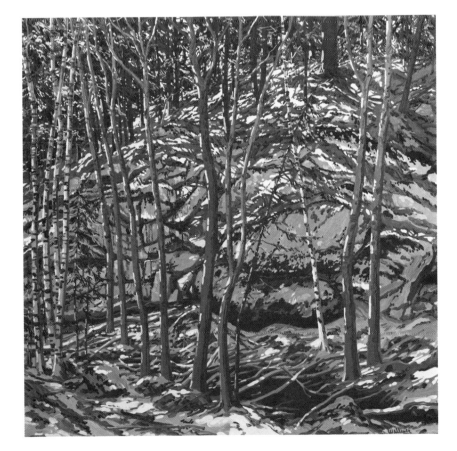

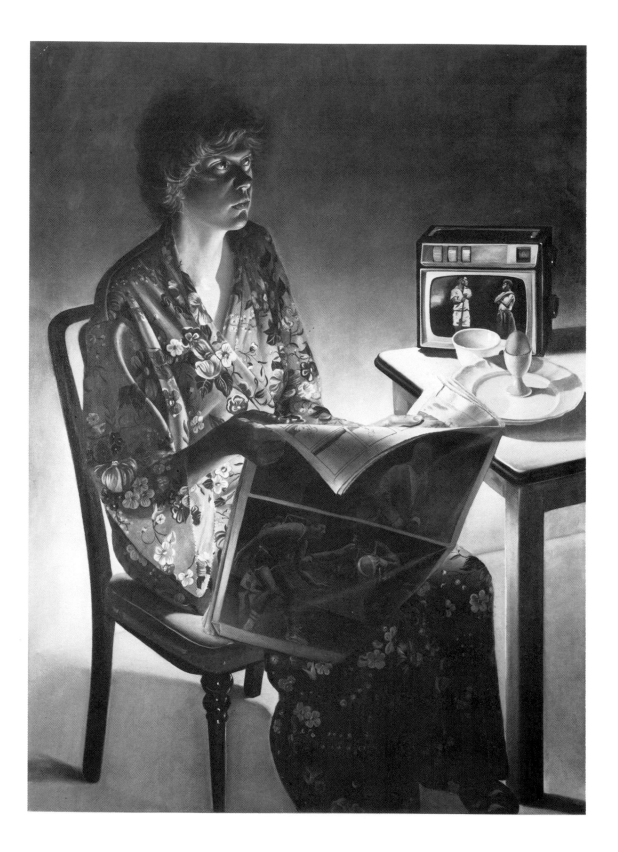

Alfred Leslie
American, born 1927
Seven A.M. News
1976–78
Oil on canvas
84 x 60″ (213.4 x 152.4 cm)
Collection of Mr. and Mrs.
Joseph D. Shein

Chuck Close
American, born 1940
Gwynne
1982
Watercolor on paper mounted
on canvas
74¼ x 58¼" (188.6 x 148 cm)
Private collection

Alex Katz
American, born 1927
Trio
1975
Oil on canvas
72 x 96" (182.9 x 243.8 cm)
Private collection

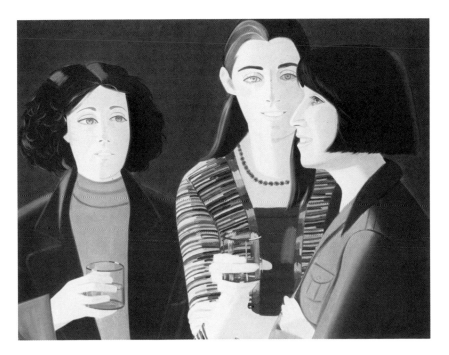

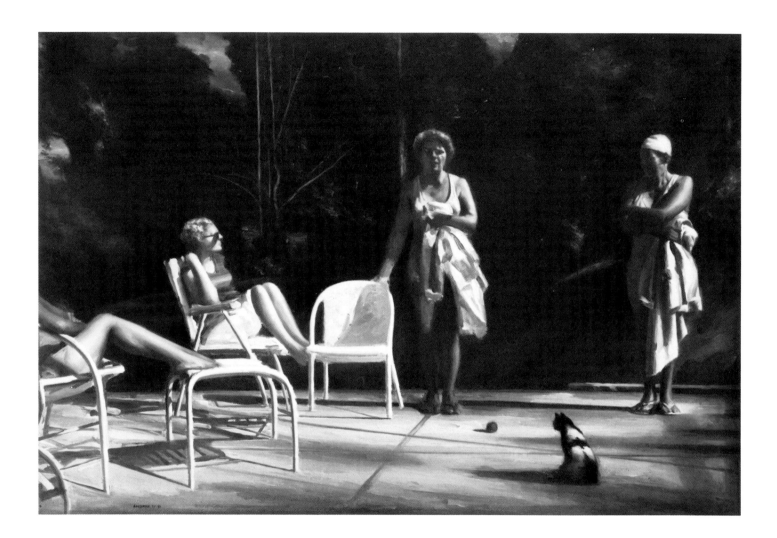

Sidney Goodman
American, born 1936
Poolside Evening
1977—81
Oil on canvas
25 x 36″ (63.5 x 91.4 cm)
Collection of Dr. and Mrs.
Robert S. Pressman

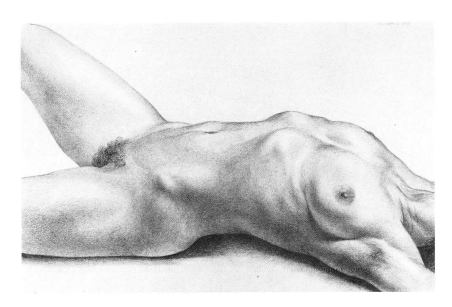

Martha Mayer Erlebacher
American, born 1937
Red Torso No. 142
1976
Pencil and chalk on paper
12½ x 19″ (31.8 x 48.3 cm)
Collection of Mr. and Mrs.
B. Herbert Lee

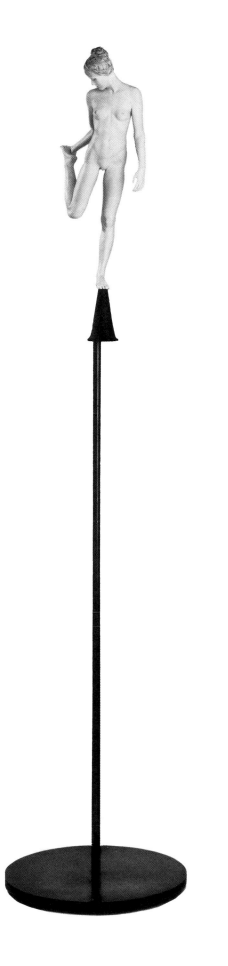

Robert Graham
American, born 1938
Lise, Dance Figure II
1980
Painted bronze
Height 92″ (233.7 cm)
Collection of Edna S. Beron

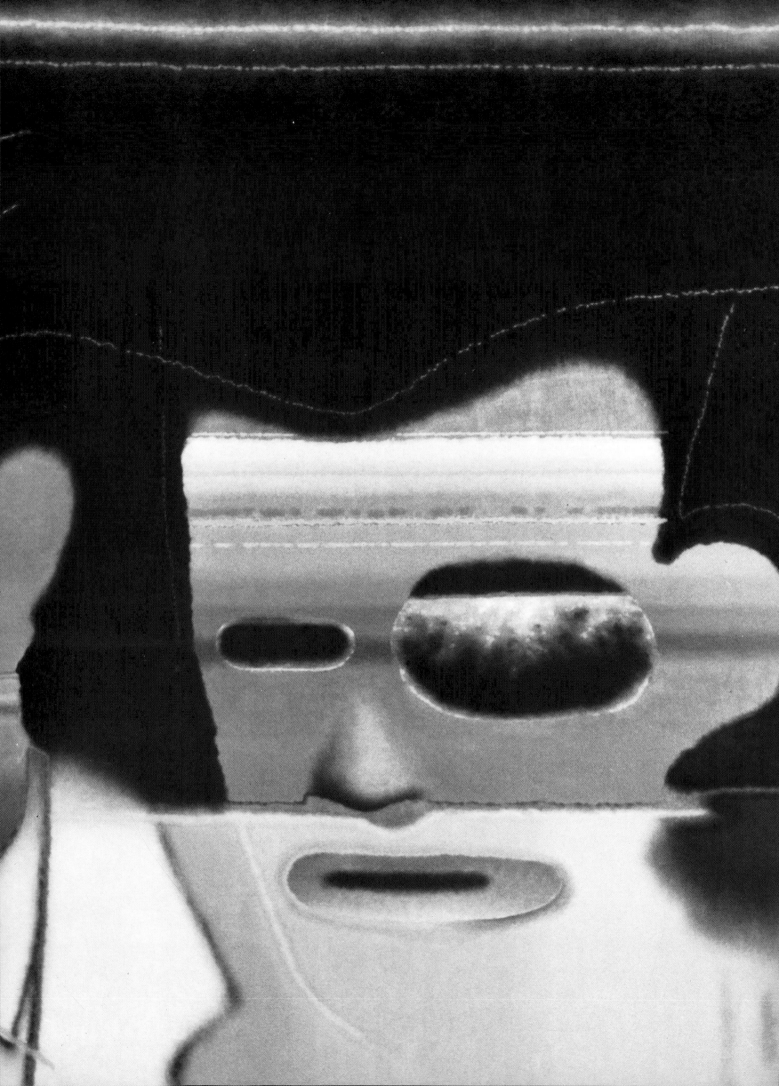

NEW FORMS OF FIGURATION

Artists today work with a multiplicity of mediums and methods, inventing images and formulating or appropriating styles in this decade's own spirit. No single mode emerges as dominant, but notable within this diversity is a renewed interest on the part of many artists in strengthening the relationship between art and society. Social and political commentary recurs as subject matter, and artists take on issues of global significance in works whose content and surfaces are emotionally and visually charged. Jonathan Borofsky's confrontational, multisensory installations and Robert Longo's jarring juxtaposition of images accentuate cultural "points of stress" and demand the viewer's interaction and response. Anxieties and fantasies specific to our generation emerge variously in Jean Michel Basquiat's frenetic graffiti and Cindy Sherman's photographic personas. Other artists have resumed a search for meaning in their national pasts. Historical and cultural self-examination permeates much of the work of Italians Sandro Chia, Enzo Cucchi, and Francesco Clemente, and the highly wrought, allusive canvases of German painter Anselm Kiefer. The diversity of images presented here reflects the varied ways in which artists seek to locate and describe meaning in a precarious world.

Ed Paschke
Bibutsu (detail)

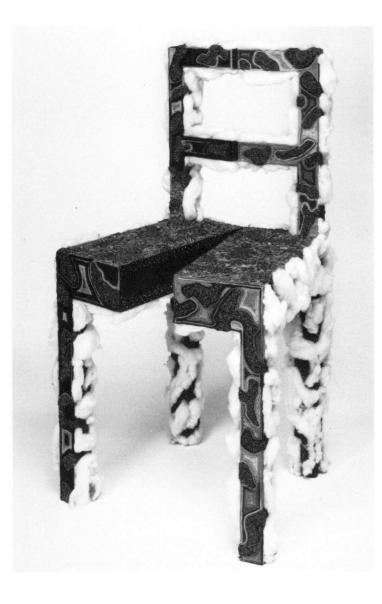

Lucas Samaras
American, born Greece, 1936
Chair Transformation No. 19
1969–70
Paint, cotton, wool, beads, and
wood shavings on wood
Height 42″ (106.7 cm)
Collection of Eileen Rosenau

Lucas Samaras
American, born Greece, 1936
Untitled
1974
Pastel on paper
13 x 10″ (33 x 25.4 cm)
Private collection

Richard Artschwager
American, born 1923
Shelter at Edge of Forest III
1974
Graphite on Celotex
53 x 31" (134.6 x 78.7 cm)
Collection of Henry S.
McNeil, Jr.

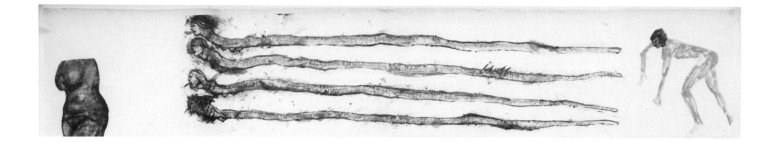

Nancy Spero
American, born 1926
Monsters
1972, 1979, 1984
Gouache and collage on paper
20 x 108" (50.8 x 274.3 cm)
Collection of Harvey and Judy
Gushner

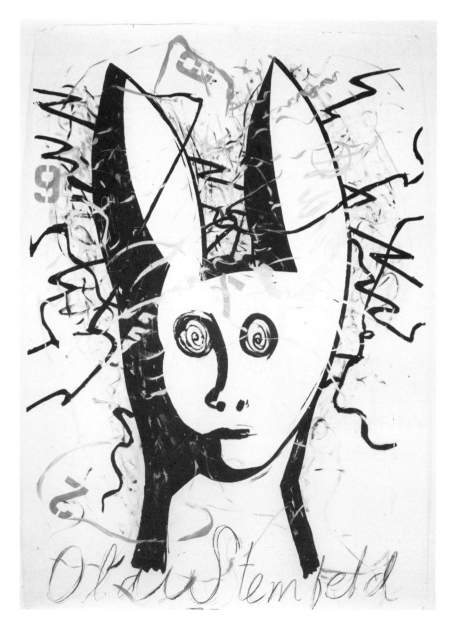

Jonathan Borofsky
American, born 1942
Oldi Sternfeld at 2,738,441
1982
Acrylic, charcoal, and pencil
on paper
91 x 60" (231.1 x 152.4 cm)
Collection of Harvey and Judy
Gushner

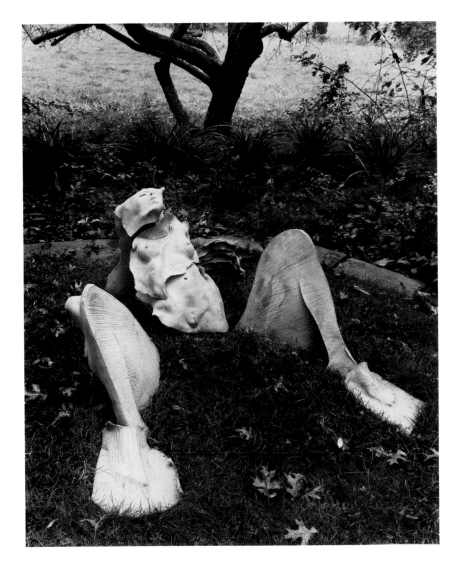

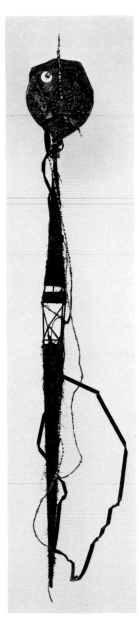

Mary Frank
American, born Great Britain,
1933
Woman
1978
Ceramic (eight sections)
Height 23″ (58.4 cm)
Collection of Eileen Rosenau

Rafael Ferrer
American, born Puerto Rico,
1933
*The Arrogant Man from the
Tropics*
1975
Metal, beads, twine, paint, and
fabric
Height 68½″ (174 cm)
Collection of H. Gates Lloyd

Roger Brown
American, born 1941
Winter Tailgate
c. 1975
72 x 48" (182.9 x 121.9 cm)
Oil on canvas
Collection of Mr. and Mrs.
Burton K. Stein

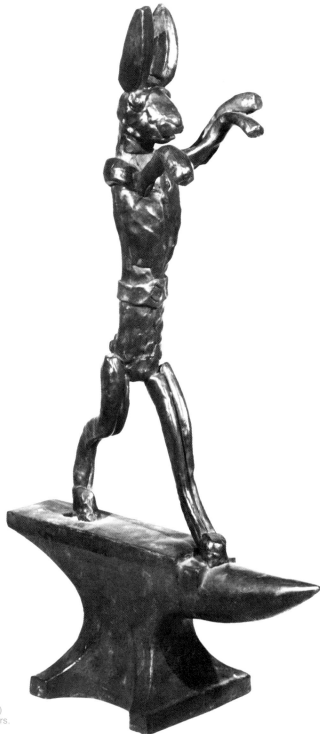

Barry Flanagan
British, born 1941
Hare on Anvil
1982
Bronze
Height 40⅛" (101.9 cm)
Collection of Mr. and Mrs.
Benjamin Frankel

Joe Zucker
American, born 1941
Upper Midwest
1975
Rhoplex and saffron on
canvas
48 x 48" (121.9 x 121.9 cm)
Collection of Henry S.
McNeil, Jr.

Ed Paschke
American, born 1939
Bibutsu
1982
Oil on canvas
80 x 96" (203.2 x 243.8 cm)
Collection of Mr. and Mrs.
Joseph D. Shein

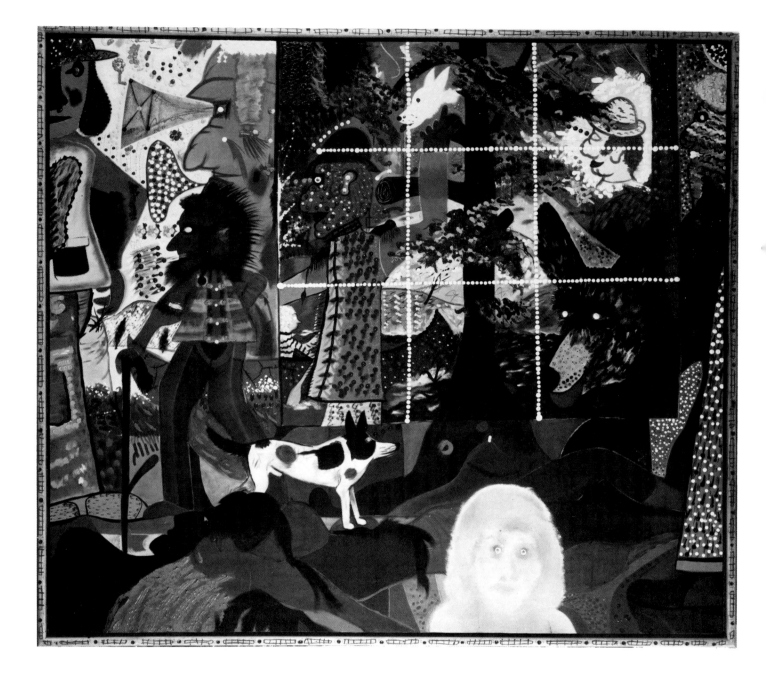

Roy De Forest
American, born 1930
View of Lake Louise
1979
Polymer on canvas
75½ x 87" (191.8 x 221 cm)
Collection of Mr. and Mrs.
Robert Levenson

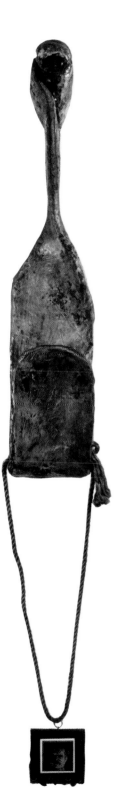

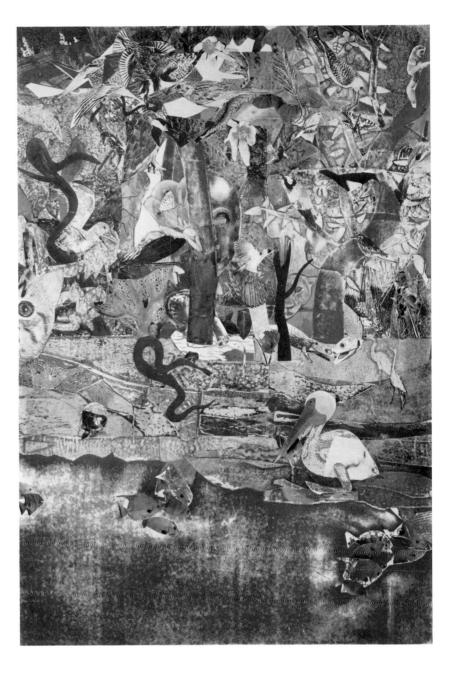

Robert Arneson
American, born 1930
Picture Hook
1971–73
Fiberglass, ceramic, and tile
91 x 12 x 10″ (231 x 30.5 x
25.4 cm)
Collection of Mr. and Mrs.
Nathaniel H. Lieb

Romare Bearden
American, born 1914
The Blue Snake
1971
Collage of printed and painted
paper on board
36 x 23¾″ (91.4 x 60.3 cm)
Promised gift of Priscilla Grace
to the Philadelphia Museum
of Art

Georg Baselitz
German, born 1938
Snared (Hero) [Falle (Held)]
1966
Oil on canvas
64 x 51¼" (162.6 x 130.2 cm)
Private collection

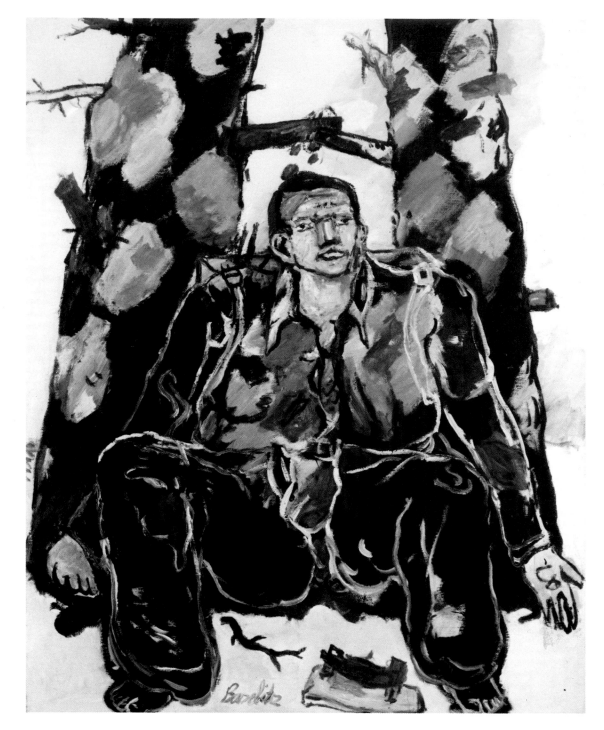

Gerhard Richter
German, born 1932
Candle
1982
Oil on canvas
39½ x 39¼" (100.3 x 99.7 cm)
Collection of H. Gates Lloyd

Jörg Immendorff
German, born 1945
We Can Be Satisfied II
[Wir Können Zufrieden Sein II]
1981
Oil on canvas
64¼ x 47⅜"
(163.2 x 120.3 cm)
Collection of Mr. and Mrs.
Robert Lee

Anselm Kiefer
German, born 1945
The Three Fates: Urd,
Werdandi, Skuld [Die Drei
Nornen: . . .]
1979
Oil on canvas
98½ x 59″ (250.2 x 149.9 cm)
Collection of Harvey and Judy
Gushner

Anselm Kiefer
German, born 1945
Yggdrasil
1985
Lead, acrylic, emulsion, and
shellac on photograph
40½ x 32⅞"
(102.9 x 83.5 cm)
Collection of Mr. and Mrs.
Stephen H. Frishberg

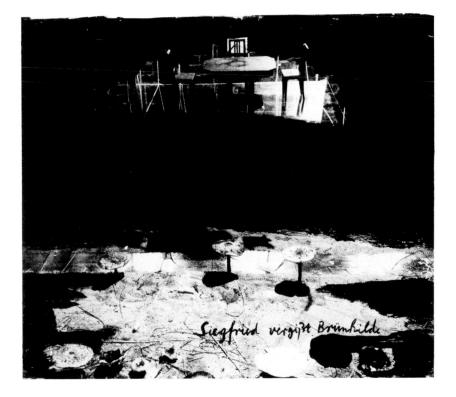

Anselm Kiefer
German, born 1945
Siegfried Forgets Brünhilde
1978
Oil on photograph
19½ x 22½" (49.5 x 57.2 cm)
Private collection

Mimmo Paladino
Italian, born 1948
Untitled (Muses)
1981
Acrylic and papier-mâché on
paper
62 x 42½″ (157.5 x 108 cm)
Collection of Henry S.
McNeil, Jr.

Enzo Cucchi
Italian, born 1950
Soon, the Gift of a Storm
1981–82
Oil on canvas
4′5¼″ x 11′2″ x 6″
(1.4 x 3.4 x .2 m)
Private collection

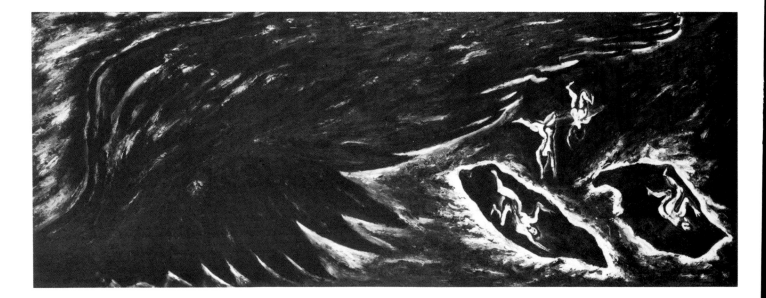

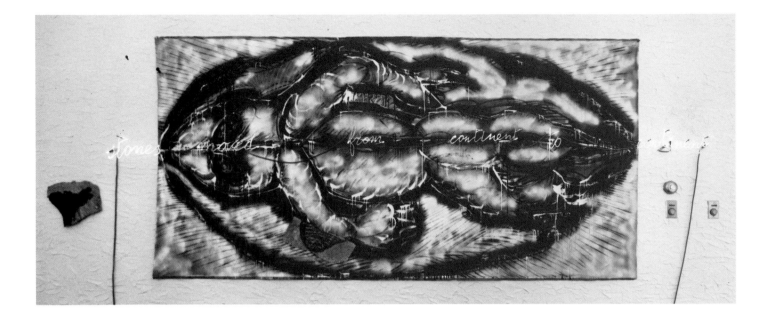

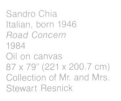

Mario Merz
Italian, born 1925
*Stones Moved from Continent
to Continent*
1983–84
Acrylic, oil, and spray enamel
on unstretched canvas with
neon and with enamel and
charcoal on rock
5'1" x 10' (1.5 x 3 m) (canvas)
Collection of Harvey and Judy
Gushner

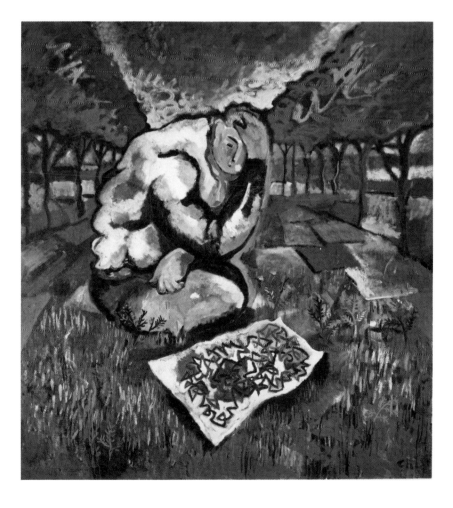

Sandro Chia
Italian, born 1946
Road Concern
1984
Oil on canvas
87 x 79" (221 x 200.7 cm)
Collection of Mr. and Mrs.
Stewart Resnick

Francesco Clemente
Italian, born 1952
Midnight Sun No. 5
1982
Oil on canvas
78¾ x 98¾" (200 x 250.8 cm)
Collection of Mr. and Mrs.
David Pincus

Jody Pinto
American, born 1942
Split Lips in a Landscape
1979
Watercolor and pencil on
paper
29¾ x 39¾" (75.6 x 101 cm)
Collection of Rachel Bok
Goldman

Jean Michel Basquiat
American, born 1960
Untitled (Chinese Man)
1981
Acrylic on canvas
48 x 36″ (121.9 x 91.4 cm)
Collection of Henry S.
McNeil, Jr.

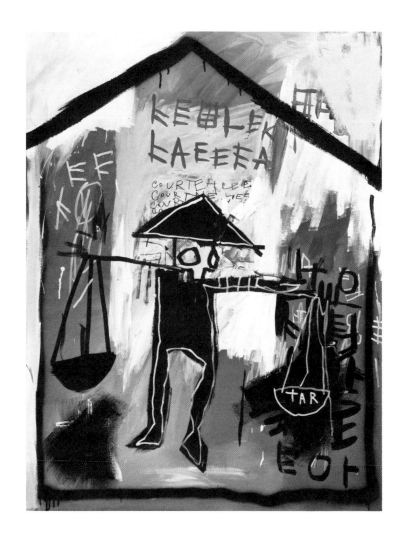

Marcy Hermansader
American, born 1951
A Place in Time
1982
Pencil, acrylic, and crayon on
paper
24¼ x 27½″ (61.6 x 69.9 cm)
(sight)
Collection of Mr. and Mrs.
B. Herbert Lee

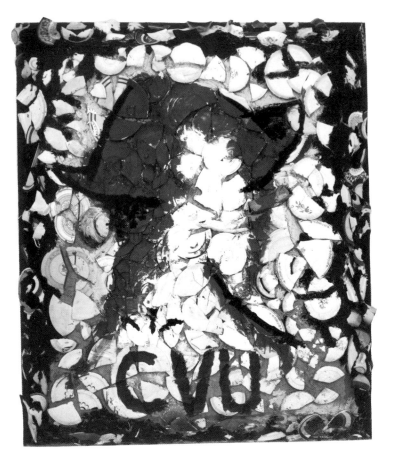

Julian Schnabel
American, born 1951
CVU
1985
Oil, ceramic, and Bondo on
wood
72 x 60 x 9″ (182.9 x 152.4 x
22.9 cm)
Collection of Mr. and Mrs.
David Pincus

Tom Chimes
American, born 1921
Rrose Selavy
1975
Oil on panel
9 x 6¾″ (22.9 x 17.1 cm)
Collection of Deborah
Allen-Hamalainen

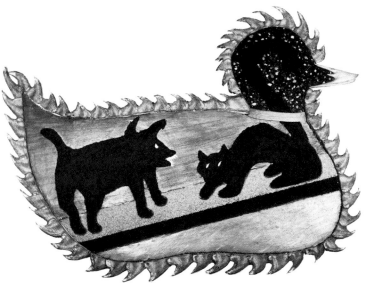

Maurie Kerrigan
American, born 1951
*Flaming Mallard
Confrontation*
1980
Oil on wood, fresco,
linoleum, roofing asphalt, and
papier-mâché
38 x 52 x 1½″
(96.5 x 132.1 x 3.8 cm)
Collection of Jay
Richardson Massey

Nancy Graves
American, born 1940
Lacinate
1983
Bronze with polychrome patina
Height 54″ (137.2 cm)
Collection of Edna S. Beron

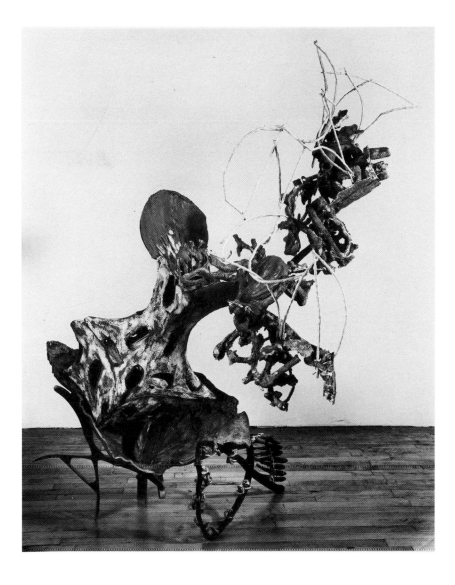

Alexa Kleinbard
American, born 1952
*She Ironed, He Typed,
They Drank*
1980
Acrylic on Celluclay and
Rhoplex mulch on plywood
28 x 61 x 10″ (71.1 x 154.4 x
25.4 cm)
Collection of Mr. and Mrs.
Theodore R. Aronson

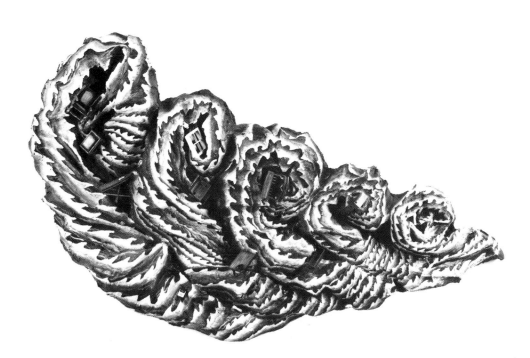

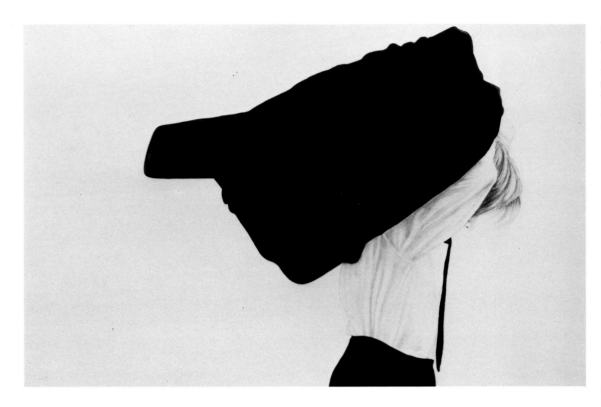

Robert Longo
American, born 1953
Untitled (Alien)
1980
Fabricated chalk and pencil on paper
39½ x 59½" (100.3 x 151.1 cm) (sight)
Collection of Henry S. McNeil, Jr.

Cindy Sherman
American, born 1954
Untitled No. 122
1983
Ektachrome print
34½ x 21" (87.6 x 53.3 cm) (sight)
Private collection

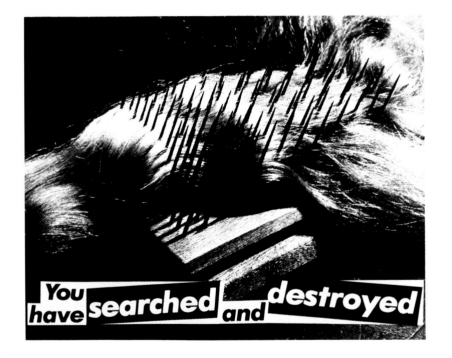

Barbara Kruger
American, born 1945
You Have Searched and Destroyed
1982
Gelatin silver print
40 x 49" (101.6 x 124.5 cm)
Collection of Henry S. McNeil, Jr.